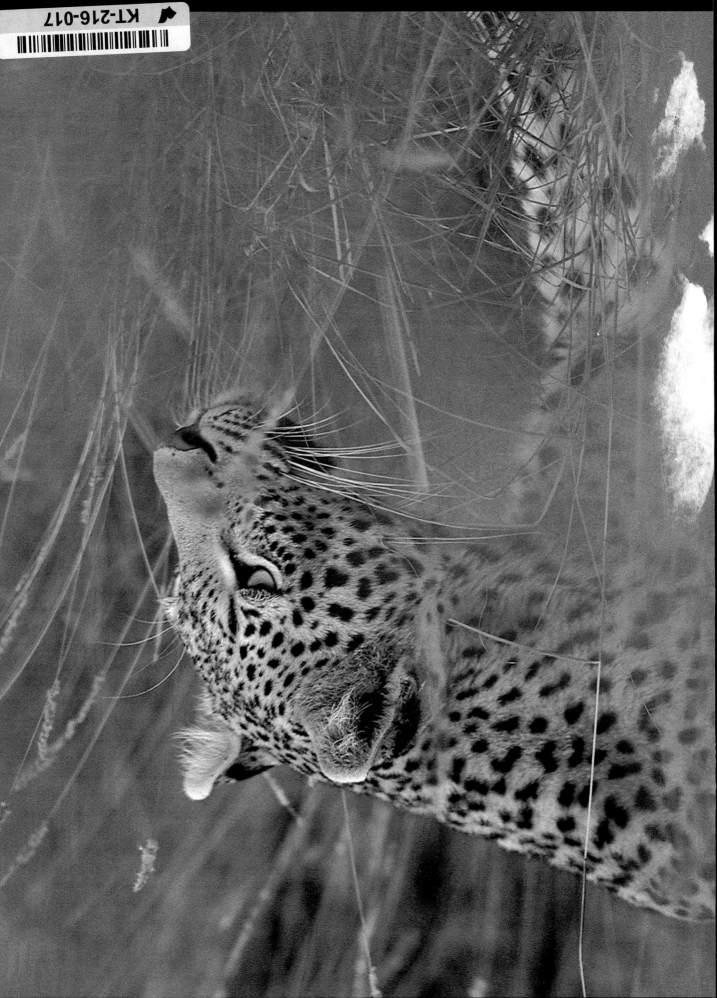

SOUTH AFRICA

BOTSWANA

NAMIBIA

Kgalagadi NP

Upington

Augrabies Falls NP

Orange

Kimberley

Namaqualand

Fynbos

Cape of Good
Hope NP

CAPE TOWN

Fynbos

Contents

Namaqualand 6
The Cape 11
Fynbos 20
Kgalagadi 26
Augrabies 37
KwaZulu-Natal 38
Blyde River Canyon 49
Kruger 51
Private reserves 65
Practical tips 70
Wildlife photography 72

Map symbols

◆ Lodges or hotels

—— Highways or main roads

--- Secondary roads (4x4)

▢ National parks and reserves

Key to photo symbols

🎥 Wide angle: from 20 to 35 mm

🎥 Middle range: from 70 to 200 mm

🎥 Long range (telephoto lens):
from 300 to 600 mm

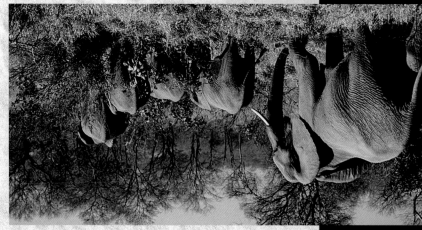

Limpopo

Kruger NP

Olifant

Blyde River Canyon NR ○
Private reserves

Sabie

Pretoria ●

JOHANNESBURG ●

Crocodile

SWAZILAND

Itala NR

St. Lucia NP

Bohlokong ●

Hluhluwe
Umfolozi P

Royal Natal NP

St. Lucia ●

Natal
Drakensberg P

mfontein ●

LESOTHO

DURBAN ●

Orange

Port Shepstone ●

East London ●

Port Elizabeth ●

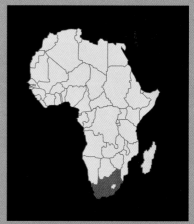

Politically isolated for several decades, South Africa has become, since the official ending of Apartheid in 1990, one of the planet's most favoured tourist destinations. This infatuation derives partly from its rich cultural heritage and partly from its remarkable natural endowments of which, more than any nation in the world, South Africa has taken great advantage. Positioned at the crossroads of African and European influence, it possesses a western infrastructure that permits the intrepid independent traveller to explore its wild landscapes in total freedom. And for more adventurous souls there are the bumpy dirt roads and steep footpaths that invite discovery as they cross its wonderful countryside. South Africa offers even the most demanding visitors the chance to live to the full their safari dream.

3

SOUTH AFRICA

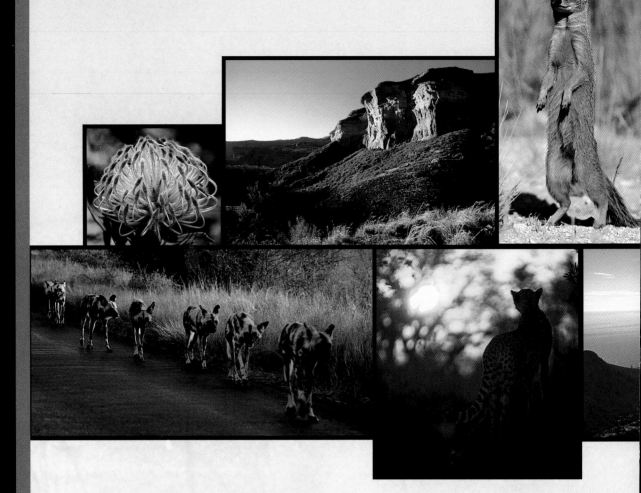

Since the Apartheid system officially ended in 1990, South Africa has successfully opened its borders to the outside world, although not all attitudes have altered at the same pace. This is because South Africa is a curious alchemy of diverse ethnic influences, where the cultures of Africa and the West converge – sometimes violently, sometimes in harmony – and make it a world apart, unique and captivating.

About 43,000,000 inhabitants live in this region of 1,122,000 square kilometres, more than twice the size of France. Situated south of the Tropic of Capricorn, the Republic of South Africa embraces all the continent's southern extremity and extends 2,000 kilometres from north to south and 1,500 kilometres from Durban, on the east coast, to Port Nolloth, on the west. Beaches reaching for thousands of kilometres are bathed on the eastern coast by the Indian Ocean and on the west by the Atlantic. In the north, the powerful Orange River forms a natural frontier with Namibia while the Molopo partly defines the Botswana border and the

Limpopo's course that of Zimbabwe. In the east, the mountainous Lebombo chain marks the border with Mozambique. There are also two small countries land-locked within South Africa: Swaziland, which shares a frontier with Mozambique, and Lesotho where the neighbouring provinces of Kwazulu-Natal, Eastern Cape and the Free State converge. Lesotho is also home to Mount Thabana Ntlenyana (3,482 metres) which is the highest point of the Drakensberg chain and this part of Africa.

Topographically, South Africa is mainly formed by a high plateau – the High Veld – with altitudes varying from 1,200 to 1,800 metres. In the east lie the mountains and basalt foothills of the Drakensberg Mountains, creating a semi-circle across almost 400 kilometres, and in the south, the mainly steep folds that descend to the narrow coastal plains are known as the Low Veld. To the northwest this vast plateau eventually gives way to the Namib and Kalahari basins before sweeping towards the tumultuous waters of the Orange River.

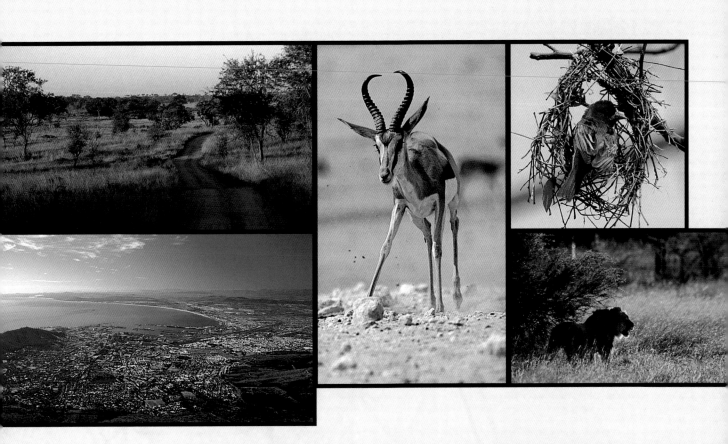

South Africa enjoys a climate that is for the most part dry and sunny but one that is punctuated by important variations, due notably to the influences of ocean and altitude. Thanks to the warm Agulhas Current and to humid winds from the Indian Ocean, the eastern side of the country experiences higher temperatures and rainfall than the west, where the influence of the cold Benguela Current, flowing north from the Antarctic, limits precipitation (and discourages swimming!). In short, the climate in the northeast is sub-tropical, while that of the High Veld is more temperate. The Cape region, on the other hand, has a dry Mediterranean climate with hot temperatures in the northwest towards the Kalahari Desert.

These climatic nuances contribute to make South Africa a country of great diversity. With its patchwork of mountains, desert, savannah, forest and beach, it possesses an exceptionally rich fauna and flora, which provide the main tourist attractions. The majority of large animals are located in the national parks where they are protected. Home to a veritable antelope kingdom of some forty species, the country also shelters the famous Big Five – lion, rhino, buffalo, leopard and elephant – which visitors are almost certain to see. Although vegetation is relatively poor in terms of forestation, this is greatly compensated for by the immense quantity of flowers that grow in all varieties and in an unbelievable proliferation of colour and perfume. Within its borders, South Africa alone hosts over 20,000 plant species, or ten per cent of the world's flora.

Although these centres of interest are scattered throughout the country, they are mostly concentrated in the Western Cape, the Kalahari Desert and the north-eastern quarter of the country, comprising KwaZulu-Natal and Mpumalanga. These are the centres presented in this publication which, though not exhaustive, we hope will help the reader, through photographs, to discover this fascinating destination and its unique African character.

Namaqualand

Straddling the provinces of Western Cape and North Cape, Namaqualand is bathed by the cold ocean Benguela Current which flows up from the Antarctic along the west coast of South Africa. The influence of the Benguela on the local climate accounts for the arid nature of Namaqualand as well as the austere scenery. Its geography is defined by a sandy coastal plain that gives way to vast inner expanses covered in short grass and extending to a distant horizon of rocky hills and mountains. This apparently inhospitable environment, however, holds a wonderful surprise. At the first sign of spring, around the months of August and September, when the heavy winter rains have fallen, the monotonous, mineral landscape is transformed, as far as the eye can see, into

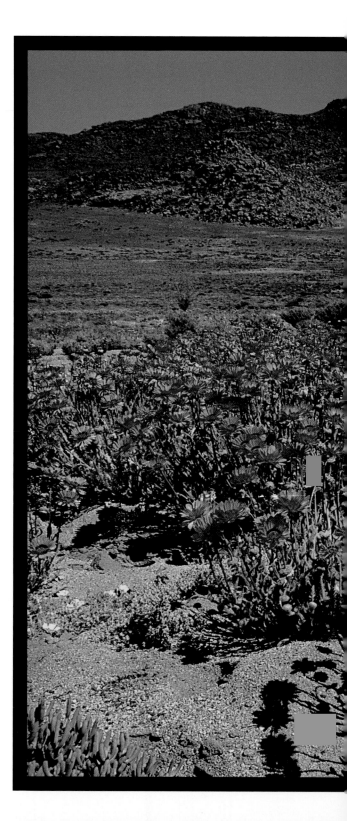

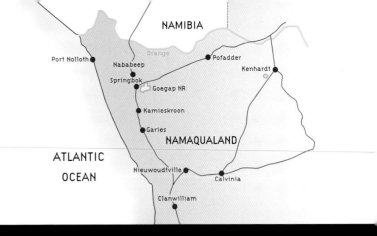

Along the Atlantic coast of North Cape Province the arid uplands of Namaqualand provide a natural theatre for an incredible spectacle. This occurs in Spring when a floral explosion transforms this setting into a sumptuous festival of colours. To photograph this phenomenon nothing less than a wide angle lens will do. A strong foreground enhances the composition and adds depth. The wide angle lens, coupled with the use of the smallest practical aperture, will ensure sharp focus from foreground to background. If a macro lens is not available, a medium long focus lens can be used to get in closer.

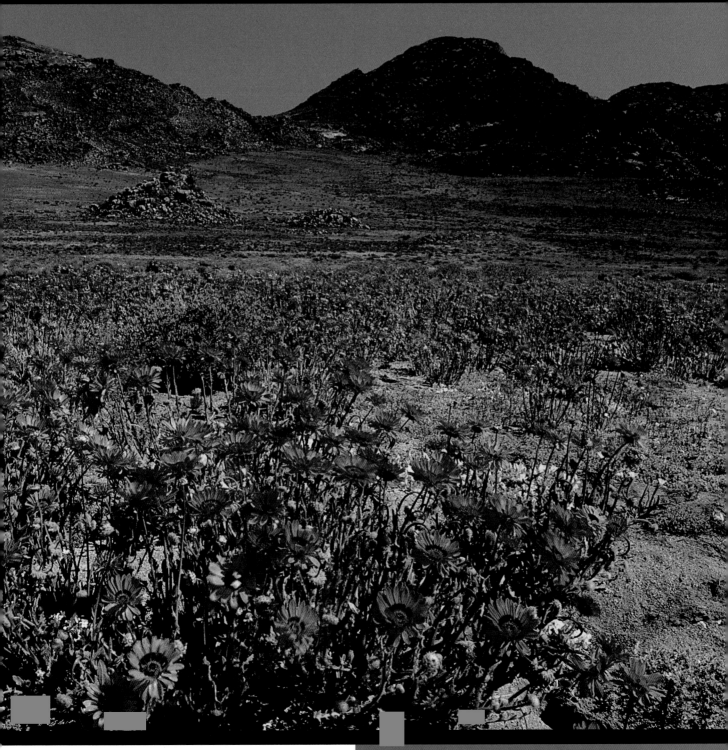

Namaqualand is home to more than 3,000 species of plant life, of which at least one-third are indigenous and belong to the succulent plant family. In 1999, the need to protect this natural heritage led the South African government to create a national park close to the town of Kamieskroon. Whether travelling on foot or by car, the floral wealth of Namaqualand abounds at every turn. Wide angle lenses are perfect for capturing the overall floral displays, whilst standard or medium telephoto lenses are ideal for moving in close to capture details.

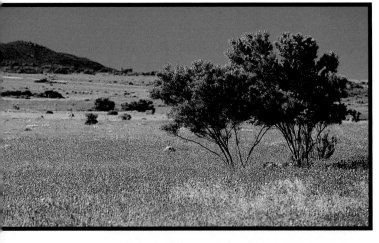

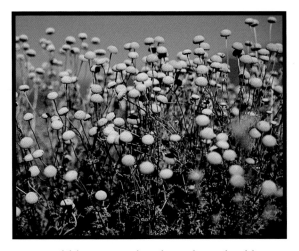

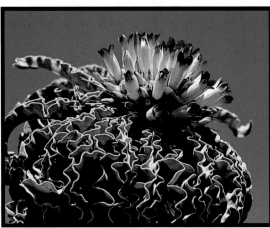

Within arid surroundings, the Goegap Nature Reserve provides fertile ground for some 200 varieties of succulents. In spring, however, as elsewhere in the region, it sees thousands of flowers opening in dazzling sheets of colour in strong contrast to the upright dramatic and stark quiver trees. A wide angle lens is again best for capturing this contrast.

an incredible carpet of multi-coloured wild flowers. Literally thousands of species, a large proportion of which are of the daisy family but also include pelargonium, gladiolus, lily, violet, oxalis and gazania. Varieties of fleshy-leafed plants (succulents) like euphorbia and aloe, grow side by side on the same terrain as the occasional quiver tree which forms a striking silhouette early and late in the day. The triangle between the large villages of Garies, Pofadder and Springbok is undoubtedly one of the best places to see this exuberent annual blooming. The Goegap Nature Reserve provides some wonderful examples. For those less interested in botany, this region also offers magnificent panoramas, notably around Pofadder, which is overlooked by a plateau of the same name, as well as between Nababeep and Port Nolloth, where a majestic escarpment dominates the coastal plane. The natural wealth of Namaqualand makes it worth devoting several days here to explore.

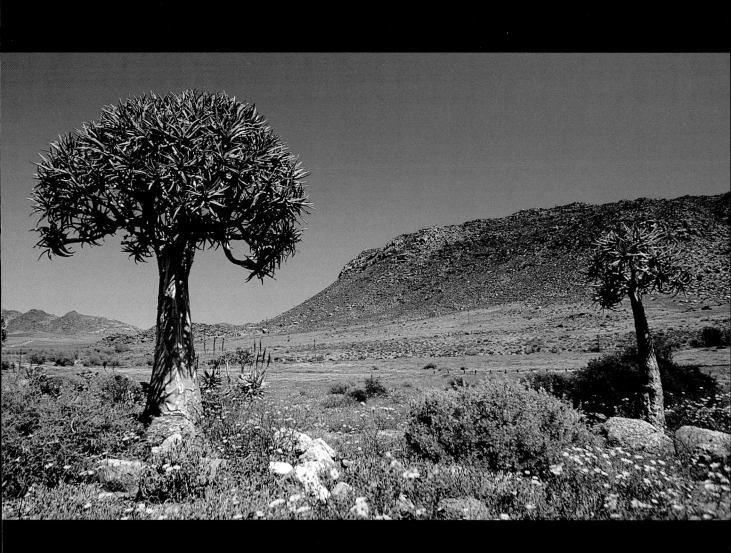

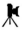

This classic view of Table Mountain is taken from Bloubergstrand, north of Cape Town. The exceptionally clear conditions, although a bit misty, allowed us to photograph with a wide angle lens the mountain without its habitual crown of clouds. On the right, the conical summit of Lion's Head also dominates the ocean city. Easily accessible, it affords dazzling viewpoints over the bay, although at sunset, Signal Hill offers a better panorama.

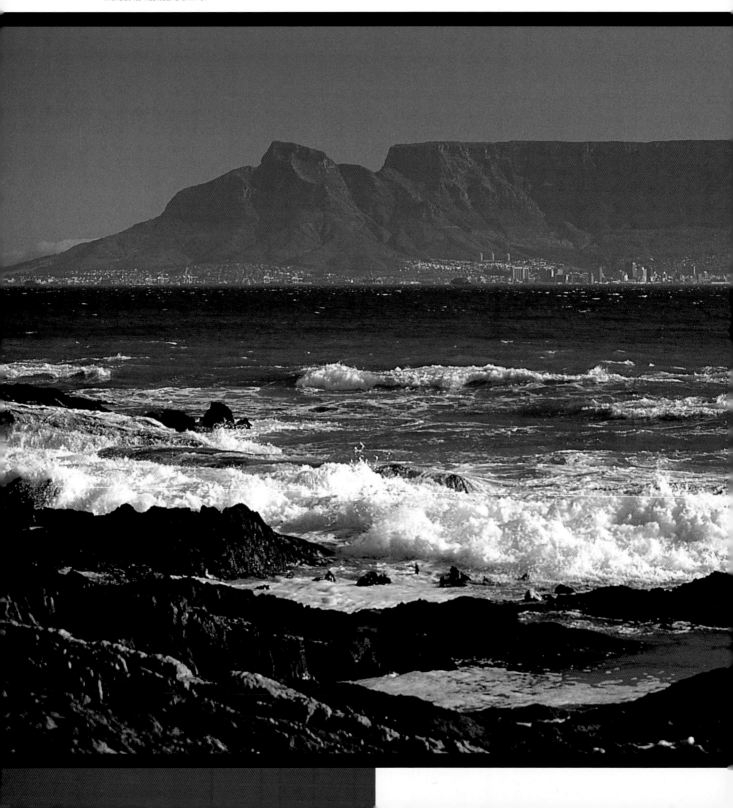

The Cape

Wellington
Worcester
Paarl
CAPE TOWN
Durbanville
Montagu
Robertson
Stellenbosch
Hottentots-Holland NR
Table Mountain NR
Marloth NR
Vrolijkheid NR
Helderberg NR
Hout Bay
Swellendam
Silvermine NR
Strand
Kirstenbosch Garden
Simon's Town
Caledon
Chapman's Peak
False Bay
Fernkloof NR
De Hoop NR
Cape of Good Hope NR
Hermanus
Bredasdorp
Gans Bay
Cape Agulhas

Swept by cold winds from the Antarctic and at the meeting point of two oceans, the continent's southern extremity possesses incomparable natural wealth. Through a mosaic of breathtaking landscapes, the Cape region shelters numerous animals that have adapted to an environment fragmented by urbanisation. Yet its many points of interest are dispersed and linked by wonderful panoramic highways. With an altitude of 1,073 metres, the monumental Table Mountain sits at the heart of a nature reserve extending for more than 208 square kilometres. Often enveloped in woolly clouds, it stands alongside other summits like Lion's Head, Signal Hill and Devil's Peak which, together, create a stunning scenic landscape magnified in the evening by the dying rays of the sun. Violent gusts of wind sweep the rocky outcrops and heavy rainfall triggers a blossoming of fynbos vegetation, manifesting through some 1,470 species, about 50 of which are

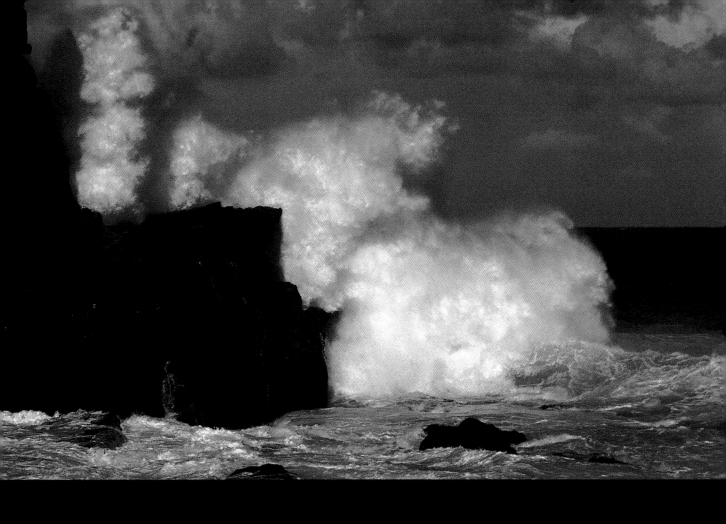

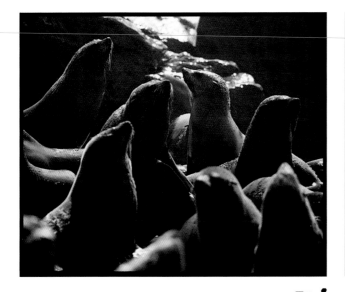

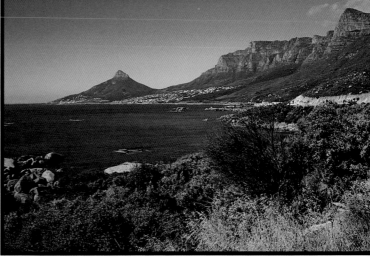

Like other islands, Duiker is the refuge of an important colony of Cape fur seals. There are thought to be more than one million along the coast of southern Africa where the Benguela Current provides abundant nourishment. To take photographs without disturbing them, a medium or long focus lens is recommended, which also helps avoid the stench! Note the impressive males which are up to three times the size of the females. Then, for a change of scene, the residential part of Llandudno is the departure point for another view of Table Mountain and Lion's Head which overlook Sainte-Helene Bay. By using a wide angle lens, it was possible to include foreground vegetation, to maintain depth of field, thus strengthening the composition.

All along the Cape coast, the explosion of waves crashing on rocks is a fascinating spectacle. Photographically, it is difficult to ignore the temptation to capture this violence and beauty. With the help of a zoom lens to bring the subject closer in the viewfinder, it is possible to concentrate the impact of the action. Provided the sunlight is good, by setting the camera at shutter speeds of or above 1/500 second, it is possible to freeze the movement of the water.

rare and endangered. The Kirstenbosch Botanical Gardens extend along the western flank and should not be missed. In spring, a multi-coloured explosion of flowers tint the mountains and attract numerous birds and insects. The fauna – shy but very visible – include hyrax, steenbok, baboons and mongooses.

Travelling south along the Atlantic coast, you reach the village of Hout Bay, departure point for excursions to the little island of Duiker where you can visit a noisy colony of Cape fur seals and Cape gannets, amongst thousands of other nesting seabirds. This sea trip also offers an opportunity to appreciate the bay and the rocky promontory known as the Sentinel that guards its entrance. Still following the coast, the Chapman's Peak panoramic route, which is cut into vividly-coloured mountain sedimentation, unveils unique views of the bay and ocean. South of the peninsula lies the Good Hope Nature Reserve, which covers an area of 77 square kilometres and has a

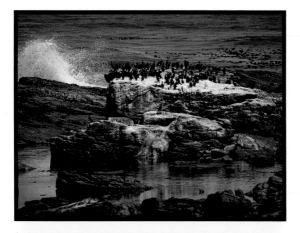

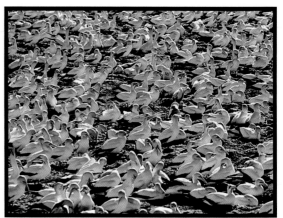

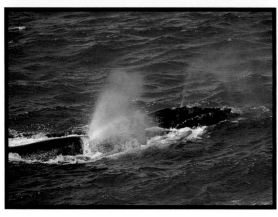

There is no need to take a boat to watch these southern right whales. At Whale Rock in Hermanus you won't be alone watching the ballet of these giants in the calm waters of the bay. The dark skin, V-blow, pectoral flippers and complete lack of a dorsal fin make them easy to identify. Humpback whales are also present here, sometimes making prodigious leaps from the sea. Watch the surface of the water and be ready to anticipate their movements to get the best pictures. They come so close to the shore that focusing at a medium distance should enable a silhouette to be captured.

40-kilometres shoreline with superb scenery. A string of coastal hills marks its eastern boundary, while to the west the relief fades. Numerous footpaths facilitate exploration of a sanctuary in which many more secretive animals are to be found. These include eight types of antelope, among them eland and bontebok, but also baboon, ostrich and very occasionally zebra. The windswept fynbos vegetation also affords a wonderful insight into its richness. Once past this mythical cape's headland, you can return northwards along the False Bay coast and stop at Boulder's Beach. Close to Simon's Town, this beach is known around the world for its colonies of jackass penguins, hundreds of which compete for space with the tourists. The penguins leave the beach to fish in the sea. Curious and fearless, they also invade car parks and gardens.

About 300 kilometres to the north of the Cape, Lamberts Bay is worth a stop on the road from Namaqualand. Lying off this little port is Bird Island which hosts significant bird colonies, including hundred of cormorants. If you cannot get close, you'll need at least a telephoto lens to photograph them. Photographing the Cape gannets is easier. Resembling the northern gannet, which breeds on north Atlantic coasts, its Cape counterpart is equally gregarious and forms colonies of up to tens of thousand of birds. The physical surroundings here favour a medium focus lens for busier shots or a wide angle to illustrate the density of the colony.

Further up, near Kalk Bay, the small Silvermine Reserve again provides a magnificent mountain north-east are the Helderberg and Hottentots-Holland botanical reserves, which back onto red hills of the same name, and which once again offer wonderful scenery.

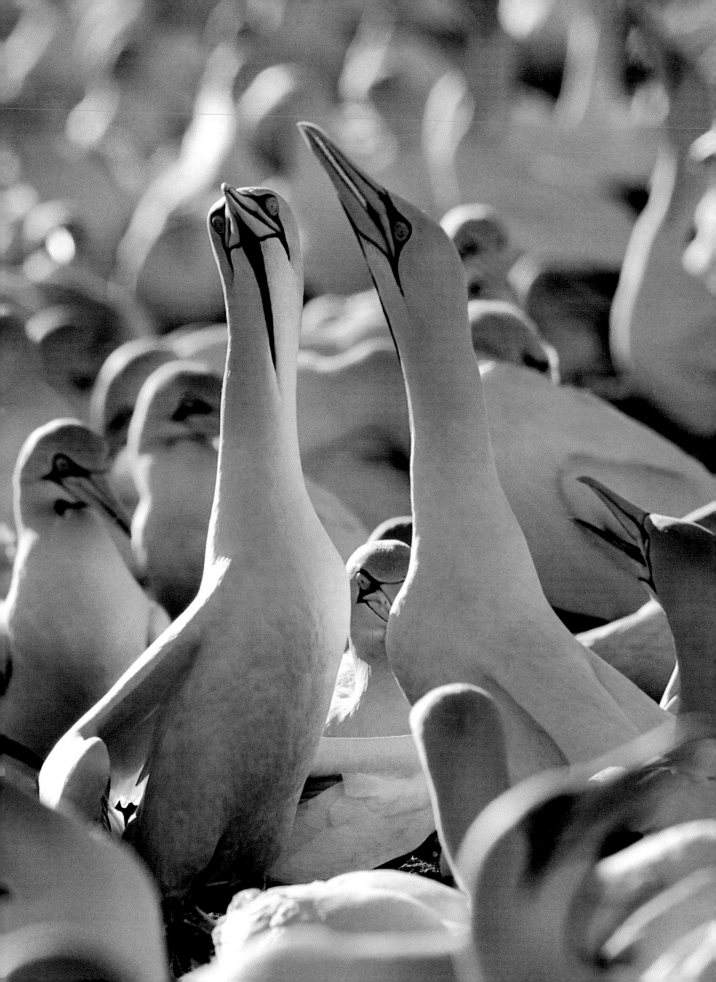

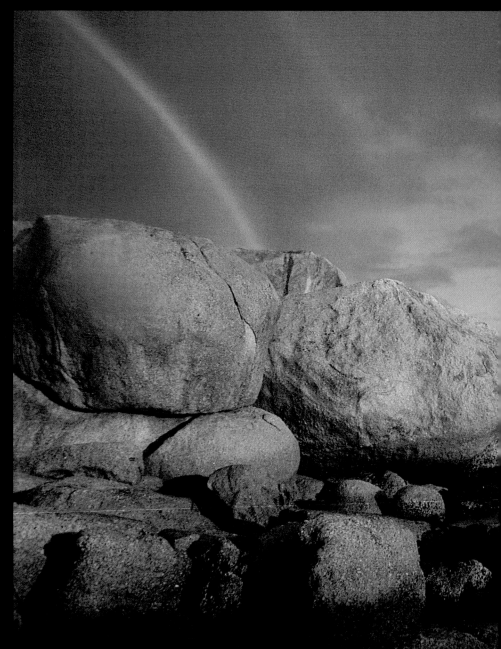

Here is an unusual picture of Boulder's Beach, where for once the famous penguins are absent. This shot reinforces the contrast and luminosity of the setting and gives it a very dramatic mood. The effect is achieved by using a wide angle lens and slight under-exposure, plus a polarising filter.

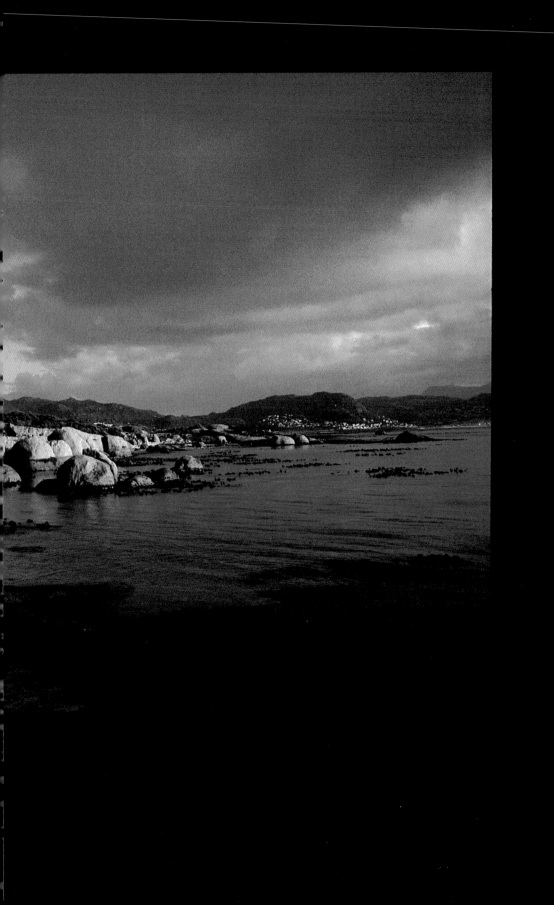

Here is an unusual shot from Table Mountain. The wide angle has allowed an accentuation of perspective through the inclusion of foreground which, in turn, is improved by its touch of colour. Even in the Cape Nature Reserve where they are used to seeing visitors, the ostriches remain shy. Therefore, the use of a telephoto lens becomes necessary. The presence of the ocean and the fynbos flowers give a certain originality to the picture. Being less timid, the hyrax will let you take his picture with a wide angle lens. This small, territorial creature lives *en famille* on rocky ledges and moves with extraordinary agility.

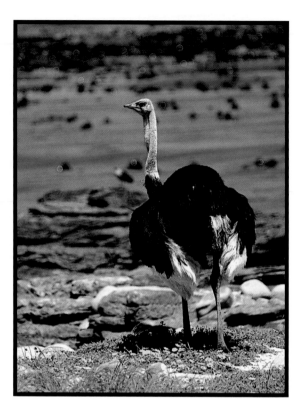

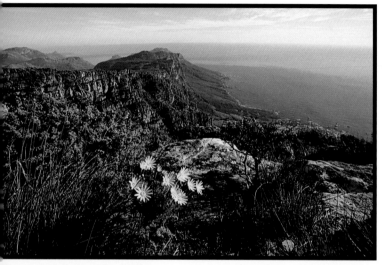

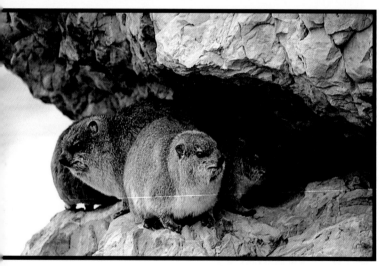

They protect eland, bontebok, common duiker and numerous kinds of birds. From there you can travel east from False Bay to reach Port Hermanus. This famous seaside resort is also the best place on the coast to whale-watch. After a long journey from the pack ice of Antarctica, these mighty mammals arrive here between June and December to lie low in the calm, warm waters of Walker Bay, close to cliffs from which they are easy to spot. Once past the famous Cape Aghulas – the continent's most southerly point where the two oceans that bathe the South African coast meet – it remains to explore the De Hoop Nature Reserve with its 410 square kilometres of deserted beach, golden dunes and jagged cliffs. Here, too, right whales have discovered a calm sanctuary and can be easily seen. The Cape is unquestionably a major tourist attraction whose rich assets fully justify its reputation.

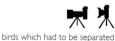

Native to the southern coasts of Africa, from Namibia to the south of Mozambique, the Cape penguin usually establishes its domain on offshore islands. But exceptions do occur as in this case at Boulder's Beach, not far from Simon's Town. There are nearly 3,000 of these curious birds which had to be separated by fences from local residents to deny them access to the town. Indeed, the ease with which they can be approached is disconcerting, but this does allow for wide-angle shots to be taken as well as close-up portraits using a medium lens.

Fynbos

Along the coast of Western Cape Province, the hilly terrain is covered by a rich carpet of vegetation which, during the springtime flowering, provides for beautifully composed pictures. But be careful; if the sky is cloudy it is best to wait for a sunny break to lighten all or part of the landscape.

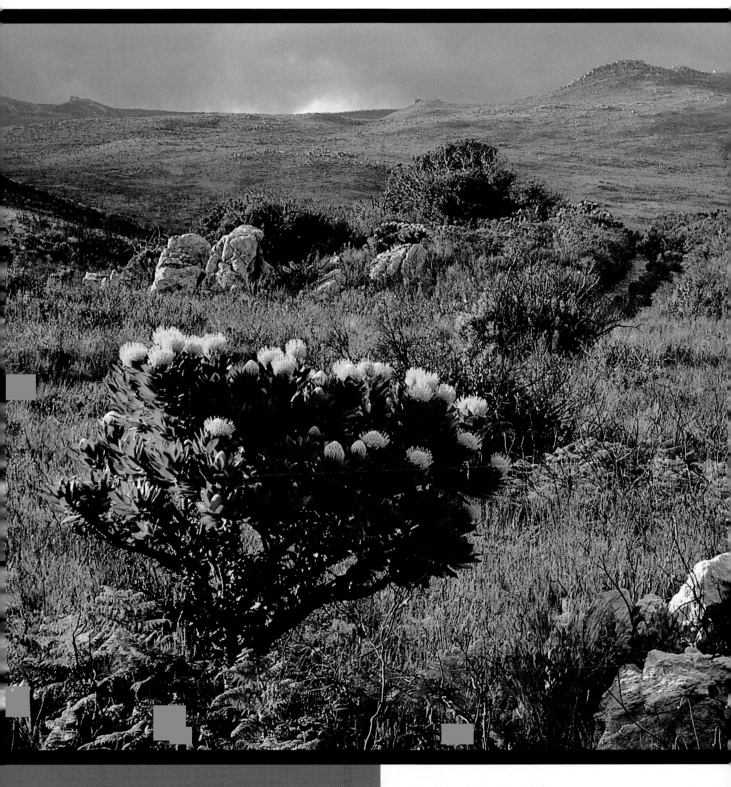

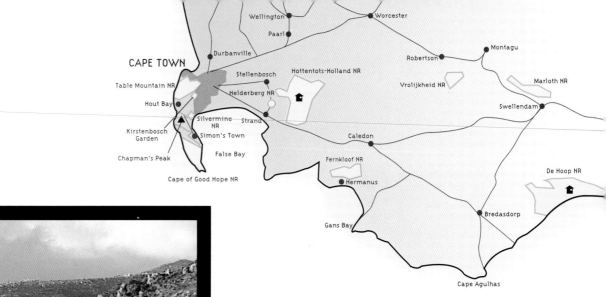

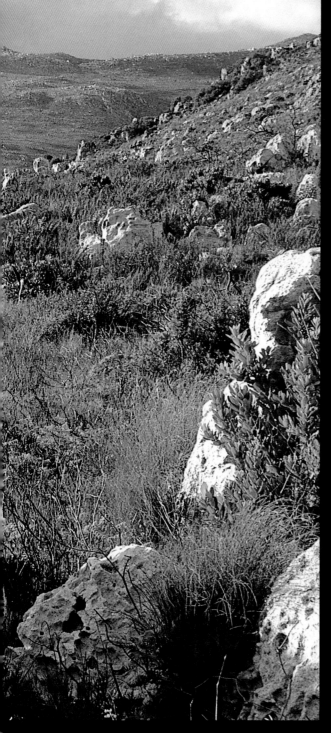

Fynbos, which is Afrikaans for a fine-leaf bush-land, is not a geographical entity, but rather a type of vegetation peculiar to Cape Province where it extends throughout most of the territory. An unparalleled wealth of variety puts The Cape among the world's six great floral domains. Nearly 8,700 plant species have been recorded here, of which 70 per cent are endemic. The fynbos is a sort of bush which grows on semi-fertile soil and whose development coincided with the disappearance, 5,000,000 years ago, of subtropical forests and the subsequent arrival of today's Mediterranean climate. It is composed of extremely varied elements, none of which dominate. Exposure to the sun and wind, together with altitude and humidity, all contribute to the growth of the fynbos, where three plant families prevail. The proteas, the symbol of the Cape flora, are characterised by high bushes with wide, tough, shiny leaves and adorned with heavy flowers composed of multitudes of tiny blossoms. The ericas or heaths belong to the heather family which typically have

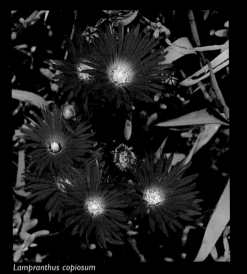

Lampranthus copiosum

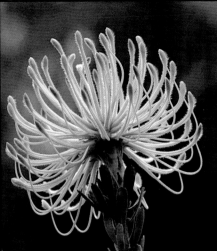

Leucospermum reflexum var luteum

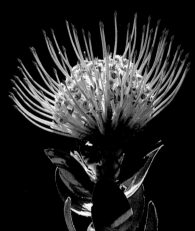

Leucospermum gueinzii

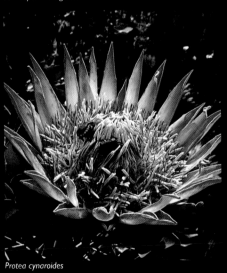

Protea cynaroides

Pelargonium betulinum

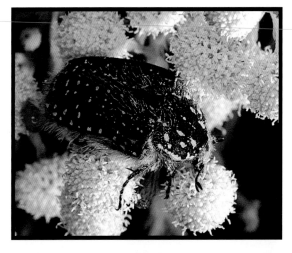

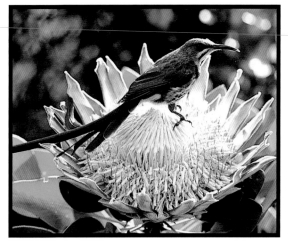

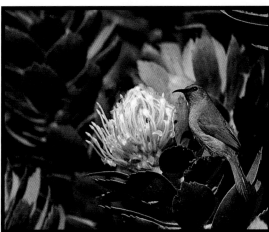

tiny tubular bell-shaped flowers and fine waxy leaves. Finally, the restios have long green stems and little brown leaves and look like reeds. Large animals are rare in the fynbos. This can be explained by a lack of nutrient vegetation and especially by urbanisation, which has extensively broken up areas where lions, leopards, elephants and hippopotamuses, among others, once roamed. Today, antelopes, together with small mammals – such as the porcupine and mongoose – and around a hundred bird species are still found. Conversely, insects – particularly butterflies, most of which are endemic– are widespread. The main locations where the fynbos can best be seen are along a hilly coastal ribbon about 200 kilometres wide extending between The Cape and Port Elizabeth. On the eastern slopes of Table Mountain, the celebrated Kirstenbosch National Botanical Garden, created in 1913, is one of the best places to appreciate this extraordinary plant life. A visit between mid-August and mid-October is the best time to see its spectacular blooming. The Cape of Good Hope Nature Reserve also offers wonderful examples of this fabulous fynbos exuberance.

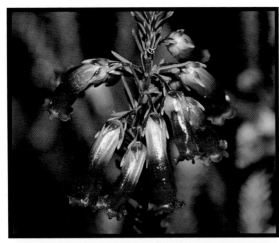

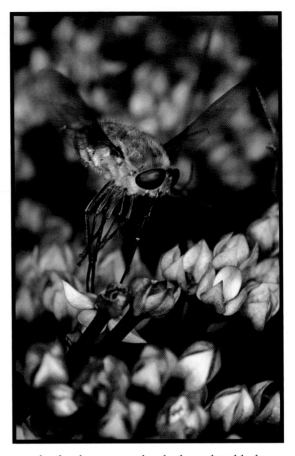

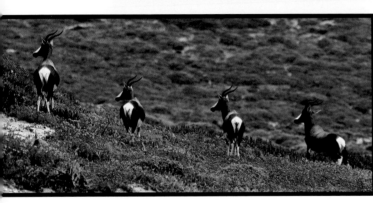

A close-up lens is indispensable to reproduce this scarlet, shining heather shot and even more for taking the insect hovering over the massed flowers. Wandering on foot in the fynbos, unexpected photo opportunities can occur, such as these bontebok within the heart of the Cape of Good Hope Reserve. This is a species of antelope that has come close to extinction and where the De Hoop Nature Reserve protects the largest population. A medium focal length lens was used to take this group shot.

Like a rich carpet of plant-life unfolding on the slopes of Table Mountain, the Kirtsenbosch National Botanical Garden constitutes the country's largest botanical reserve and is certainly one of the jewels in the crown of the Cape's floral kingdom. It occupies a magnificent natural site and is also a leisure park. A wide angle lens is ideal for including an attractive background for the portrait of flowers.

North of False Bay, in the shadow of Helderberg Mountain, is a flower reserve with unusual bushland which also embraces the nearby Hottentots-Holland Reserve. Just north of Hermanus, the Fernkloof Reserve protects a coastal stretch of fynbos which enriches the Kleinviver Mountains. Further along, on the edge of the ocean near Skipskop, is De Hoop which is the largest, and one of the most beautiful, protected areas of the region. As such, a visit here is *de rigueur* for stunning vistas, wildlife and abundant plant life. Only about 20 per cent of The Cape's floral kingdom is protected, notably the fynbos areas dominated by indigenous types. Magnificent scenery embracing one of the world's unique plant spectacles, with flowers – original in both form and colour – make this wonderful walking country.

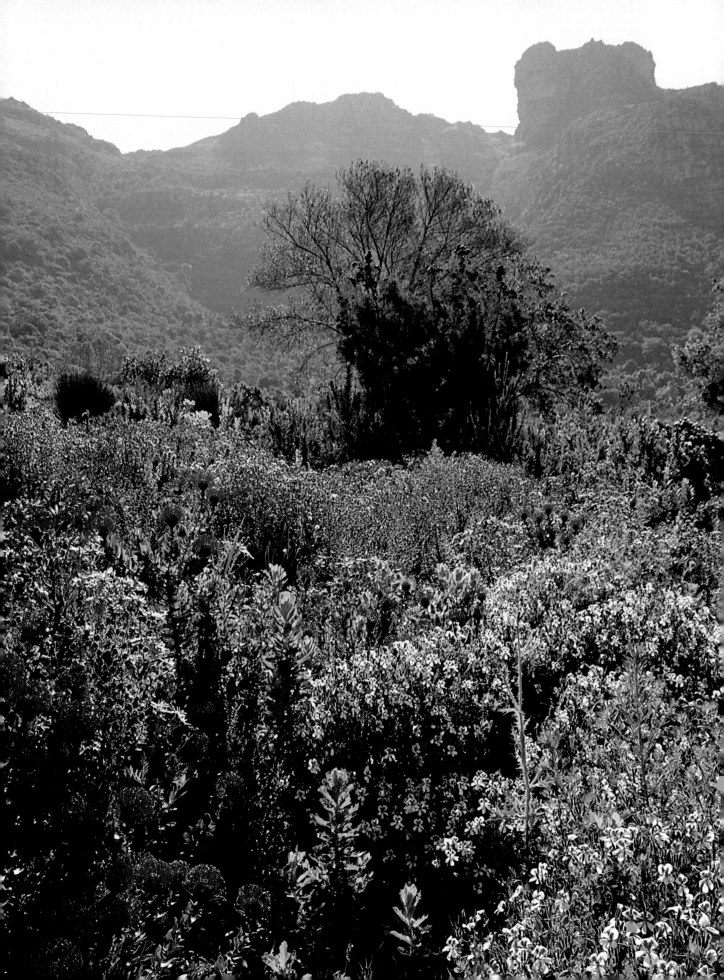

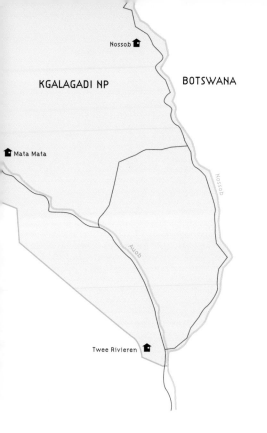

KGALAGADI NP

BOTSWANA

Nossob

Mata Mata

Auob

Twee Rivieren

Kgalagadi

Established respectively in 1931 and 1938, South Africa's Kalahari Gemsbok National Park and Botswana's Gemsbok National Park were officially merged in 1998 to form Kgalagadi Transfrontier Park, the world's first cross-border sanctuary. Jointly administered by the two countries, this protected area covers some 36,000 square kilometres of which 9,590 are in South Africa and form its second largest reserve. The park only covers a small part of the vast Kalahari Desert whose sandy basin extends into nine countries and includes a total of more than 2,500,000 square kilometres.

There are 400 kilometres of viewing trails to aid exploration. Two main routes follow the Auob and Nossob rivers while two other cross-country routes link them. Between the river beds of the Auob and

Compared to the savannah lion, the Kalahari lion has certain distinctive features. Slightly bigger than its counterparts in other regions, it boasts a darker mane and lighter coat than other wild lions. It is also better able to cope with the thirst and hunger sometimes associated with a desert habitat. For this portrait taken by the dying light of day, the animal being photographed was posing majestically close to its partner. A telephoto lens helped capture this moment in the silent and still atmosphere of the desert.

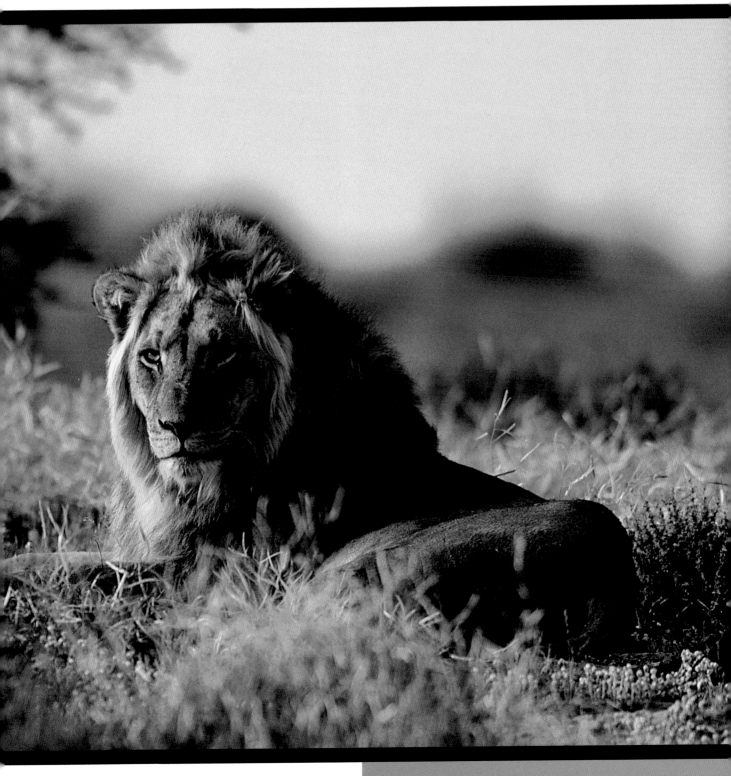

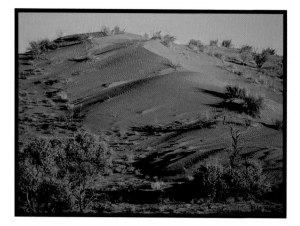

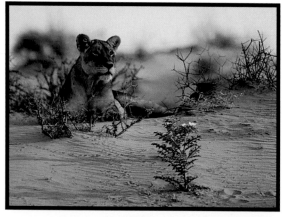

the Nossob undulates an expanse of sand dunes whose flamboyant colours stem from the high concentration of iron oxide in the soil. This is a local characteristic because beyond this region, the sandy dunes have tones of pink, grey and light buff.

The Kalahari also distinguishes itself through its plant life. Dunes often appear from beneath a dense grassy carpet and are punctuated by solitary trees and thorny bushes. Scientists say this makes the Kalahari more of a semi-savannah desert than a real desert, also because as much as 200 millimetres of rain can fall between January and April. Unlike the Namib Desert, here the wind cannot displace dunes anchored by vegetation. As in all hostile environments, the trees and plants have developed incredible powers of adaptation and resistance.

The Kalahari supports more than 400 plant species, some 215 species of birds and about 60

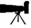

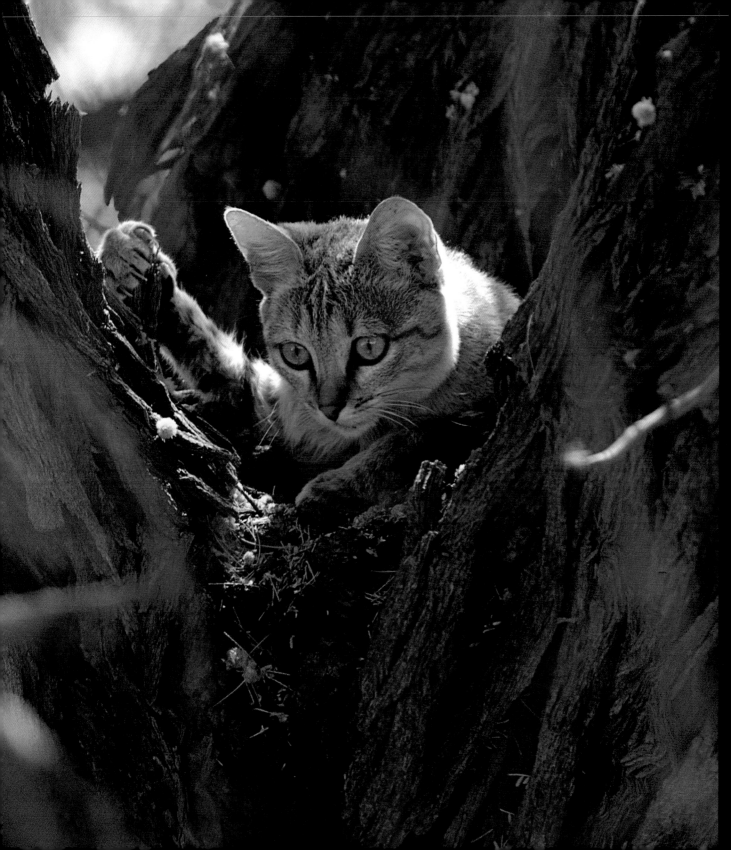

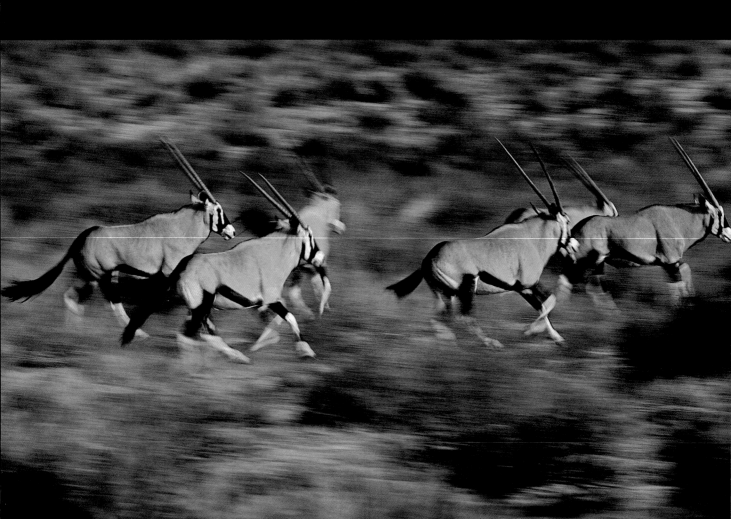

types of mammal, to which can be added numerous reptiles, insects and arthropods. When the animals move from these dunes it is usually to seasonal streams and rare waterholes where one has the best chance of seeing them. To lie patiently waiting within a vehicle can be rewarding. Absent from the park are elephants, giraffes and zebras which prefer more hospitable environments although large populations of antelopes abound. Among the latter are springbok – well adapted to this dry climate – which can be seen in their tens or hundreds. They share these hardy pastures with the gemsbok (oryx), whose long horns are a formidable weapon against predators.

The absence of a frontier between the South Africa and Botswana borders allows gemsbok, along with gnu (black wildebeest), to migrate in tandem with the rains and to find new sources of subsistence. Water is sometimes also hidden in the flesh of Tsama melons, much loved fruits of numerous herbivores, including the Cape eland, which frequent the bushy edges of rivers.

Kgalagadi is also a haunt for carnivores. Lions are naturally one of the icons of the Kalahari and it is not unusual to encounter them along the roads, which makes for easier walking than on more broken ground. True to form, the furtive leopard remains out of sight in thickets. Here, the cheetah finds large expanses devoid of obstacles, which make for easier hunting. The desert is

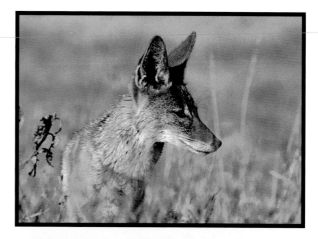

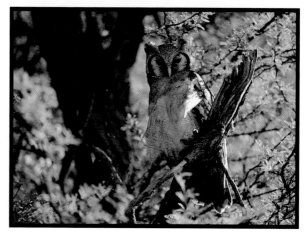

The black-backed jackal is widespread throughout Africa. In South Africa it is found equally in coastal regions, in the mountains or in the dry savannahs, most often to be seen in the early morning when the sun rises and embellishes the natural scene. To get a good portrait shot, a long focal length lens is best. The giant eagle owl is the continent's biggest owl with a wingspan of more than 1.4 metres. Confident of its mimetic plumage, it is sometimes approachable, although a telephoto is often needed because it spends most of the day on high branches.

The small picture insert opposite shows the gecko's tiny claws which act as suction pads and give it access to all sorts of surfaces often with head upside down. Just after dawn, this barking gecko was approached very quietly so the shot only needed a standard lens. The same bright light sufficed for the yellow mongoose picture which was taken with a telephoto lens in a graphic setting of dry stalks. Standard lens, several images per second triggering and priority to a slow shutter speed are the keys for a nice blur as on the picture of gemsboks galloping in the evening. But this is an effect that can be difficult to achieve.

A wide angle lens is essential for
the sky because no other lens
captures the depth and size of
cloud curtains. For animals, a
longer focus is still needed. When
it is important to freeze the
action, as in this difficult shot
illustrating the cohabitation of the
gnu and springbok around a
waterhole, don't forget to select a
faster shutter speed to avoid
blurring movement. The suricate –
alert and immobile – allows very
little time to fine tune the shot.
They live in burrows in numbers
of anything from five to 40 and
are a godsend to the birds of prey
that locate their warrens.

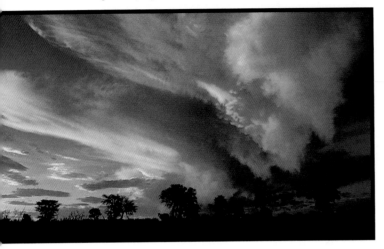

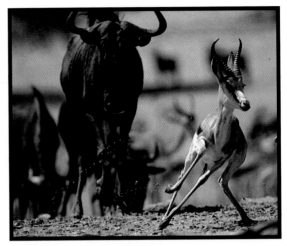

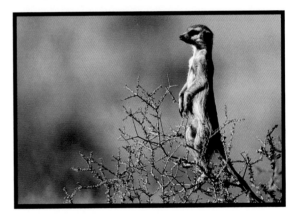

also home to the wild cat, a little feline with
whom rare encounters are always a privilege.
The canines are easier to spot, except for the
brown hyena and the aardwolf whose nocturnal
habits make them harder to locate than diurnal
species. The intrepid spotted hyena is respected
by all rivals – notably the jackal, the bat-eared
fox and the Cape fox – all of which carefully
avoid crossing its path. Only the vicious honey
badger fears nothing and nobody. It won't even
hesitate to attack a venomous snake or a giant
scorpion. Another Kalahari symbol, the suricate
(slender-tailed meerkat) is the preferred food
for numerous predators like the martial eagle,
tawny eagle and the bateleur.

The park is reputed to be one of the best places
in South Africa to watch birds of prey. Other
birds include the kori bustard – Africa's
heaviest flying bird – and the ostrich which
strolls amongst grasses ruffling the red sand

The bateleur is an eagle that
spends most of its day in flight. So
to find this couple together was
fortuitous. Although operating over
a vast area, they nest each year in
the same place. Identifiable by their
bright red claws and face, they
provide a sharp contrast to the
environment. Taken with the help of
a long focal length lens, this shot
says it all.

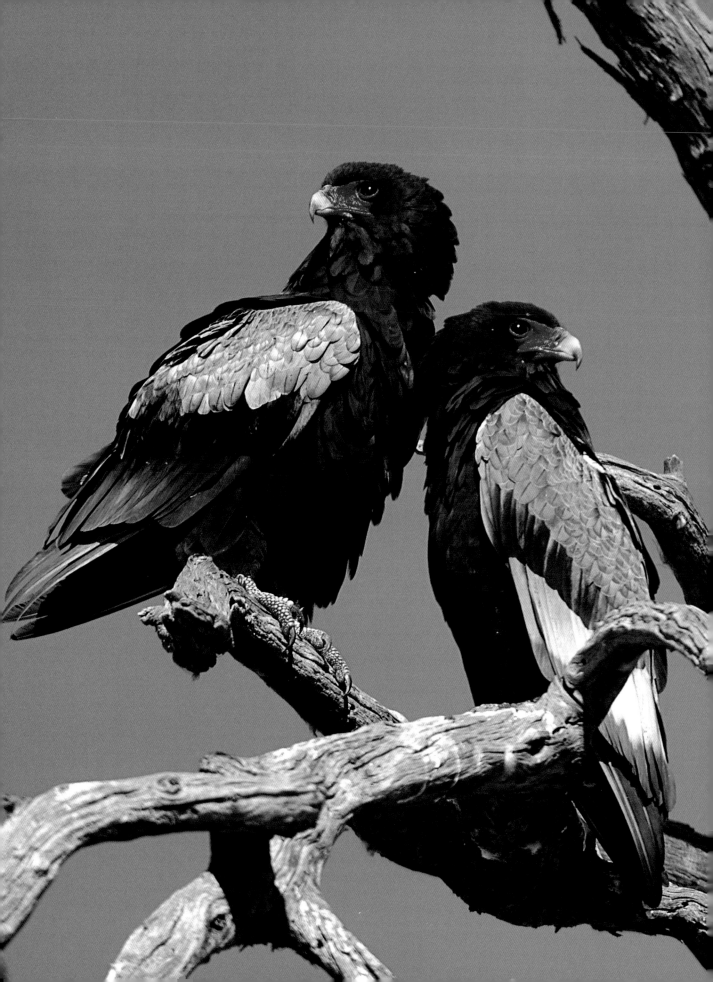

The warm light of morning is ideal for photographing animals. These Cape foxes were perfectly positioned into the sunlight, highlighting their coats, their attention riveted on their mother who is distracting a jackal with a mouse. By concentrating the light, a long focal length helps to create an atmospheric mood. As with all big felines, the evening sun is unbeatable for enhancing a cheetah's coat. To accentuate the intensity of the picture, once again it is the telephoto lens that gives the best result.

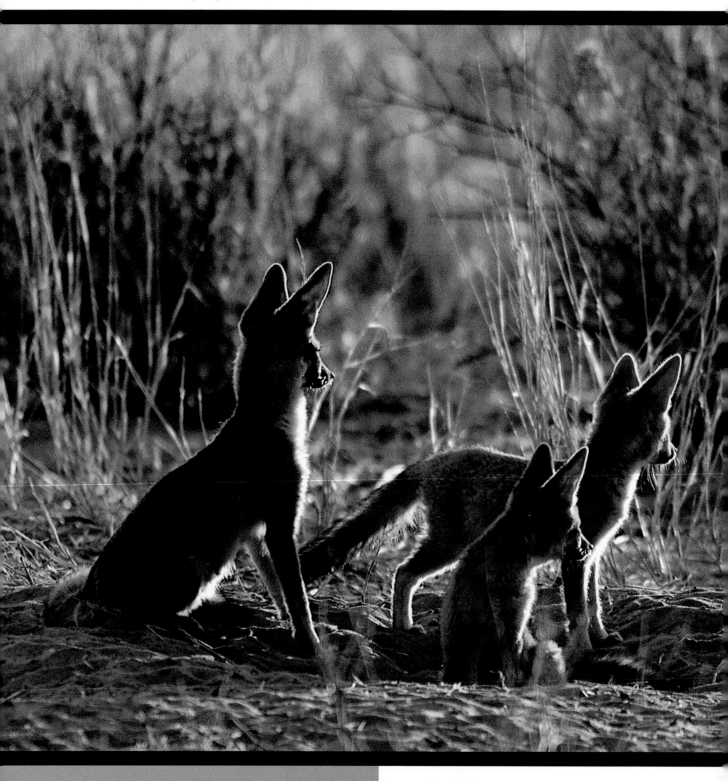

dunes. Sometimes adult ostriches are followed by a straggling line of chicks, their down covered in dust. Bee-eaters, turtle-doves and Burchell's sandgrouse are frequently seen around waterholes. Weaver birds are easily located by their enormous communal nests suspended from acacia trees. The berries and leaves of these trees are precious food for much of the fauna. Rarely visited, still secret and mysterious, the Kgalagadi Transfrontier Park is an exceptional jewel in the wildlife heritage of southern Africa that is off the beaten track and awaits your discovery.

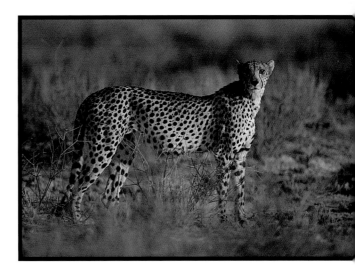

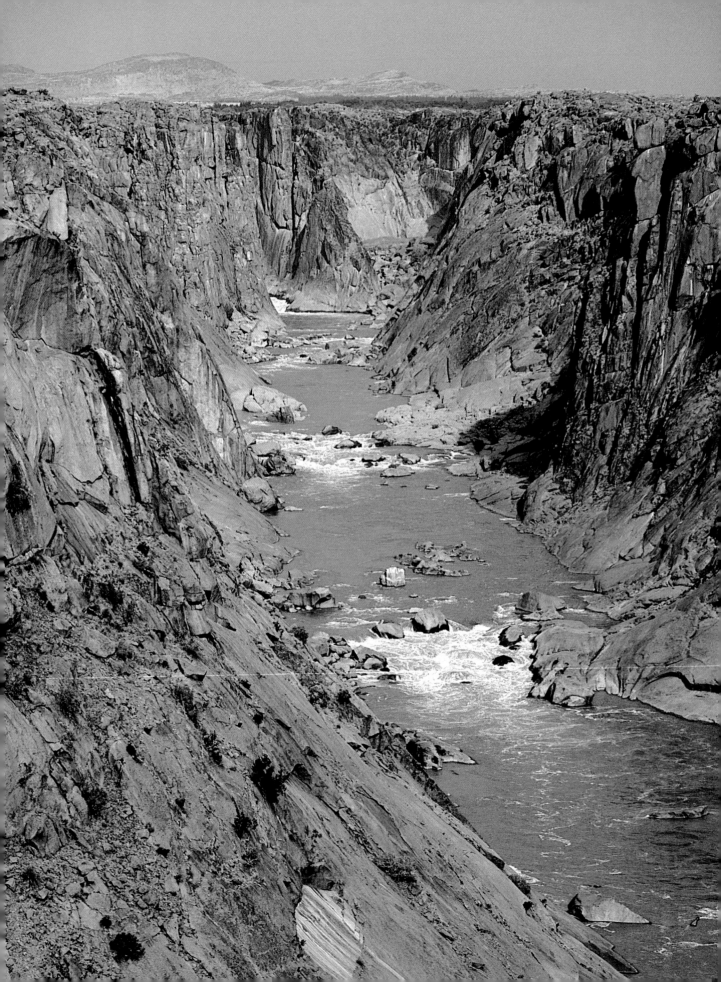

Augrabies

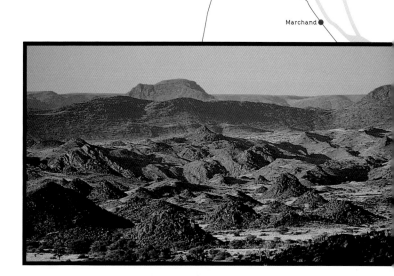

The Augrabies Falls National Park was created in 1966 and extends over 820 square kilometres. It is crossed by the strong Orange River which, rising in Lesotho, defines the border between South Africa and Namibia. Over millions of years, its flow has sculpted an 18 kilometre-granite gorge which feeds into a topographical fracture in the southeast of the park. The Orange, therefore, is forced to plunge almost 300 metres which it does in several bounds over some 10 kilometres. The roaring cataracts, the highest of which are between 50 and 75 metres, are prodigious in Summer due to rains that swell the river's flow. The park is part of the Kalahari eco-system and its vegetation is distinguished by the presence of quiver trees whose shaggy outline punctuates a mineral world overrun by thorny plantlife. The succulents retain moisture from the rains to cope with the desert heat and, by so doing, meet the needs of animals that inhabit these arid locations. Nearly 50 mammal types, mostly small in size, cohabit within the park. The rock hyrax and the ground squirrel scurry amongst ubiquitous antelopes like the springbok and the klipspringer, both very agile on rough terrain. Even though the black rhinoceros spends his days here, mostly out of sight, Augrabies is definitely not to be missed on the road to Kalahari.

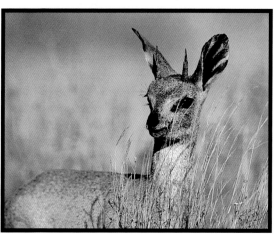

It was the ancient Nama tribes who originally baptised the Augrabies. Ankoerebis means "the place of great noise". According to legend, the Orange's bed at the falls would be carpeted with diamonds but the tumultuous noise of the waters always denies them to greedy treasure hunters. In estimating the depth and width of this scenic splendour, a wide angle lens is naturally recommended while a medium focus helps frame the lunar landscapes. As for the klipspringer, a long focal length lens equipped with teleconverter made this early morning shot possible. The animal's coat reveals the quality of light at this time of day.

KwaZulu-Natal

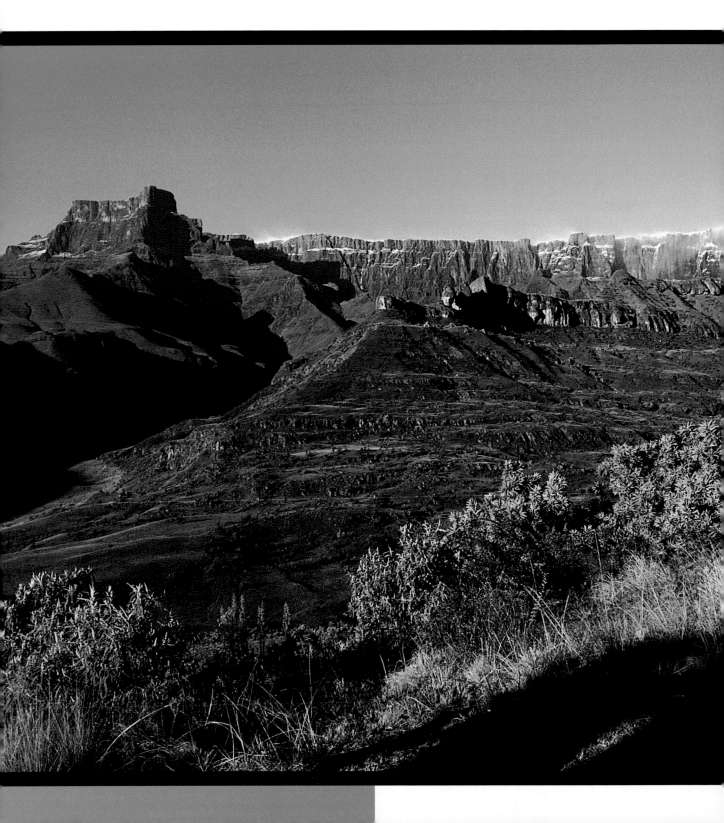

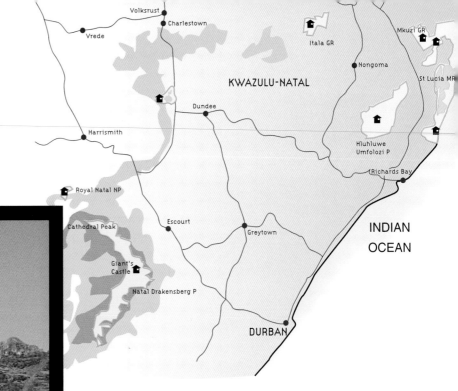

South of Royal National Park, between the Sentinel and Eastern Buttress mountains, reaching more than 3,000 metres, stands the crescent-shaped basalt wall eight kilometres wide. To get the most beautiful shot, go on foot armed with wide angle lens and a tripod to seek out the best point of view.

Volksrust
Charlestown
Vrede
Itala GR
Mkuzi GR
Nongoma
KWAZULU-NATAL
St Lucia MR
Dundee
Harrismith
Hluhluwe Umfolozi P
Richards Bay
Royal Natal NP
INDIAN OCEAN
Escourt
Cathedral Peak
Greytown
Giant's Castle
Natal Drakensberg P
DURBAN

Located in the northeast of South Africa, KwaZulu-Natal Province shelters exceptional natural sites like the spectacular Drakensberg Mountain chain, the remarkable Hluhluwe-Umfolozi and Itala wildlife reserves, the incredible St. Lucia ecosystem and the lesser known Ndumu and Tembe reserves. There are so many of these sanctuaries in which to admire the country's captivating wildlife. Known to Afrikaaners as Dragon Mountain and to Zulus as the Rampart of Spears, the Drakensberg extend for almost 400 kilometres and straddle Lesotho and Kwazulu-Natal. They comprise a string of peaks, sometimes snow-capped, and tumultuous torrents, deep valleys, misty forests and bushy moorland that embrace some fifteen reserves and national parks of which the Giant's Castle, Cathedral Peak and the Royal Natal are the most enchanting.

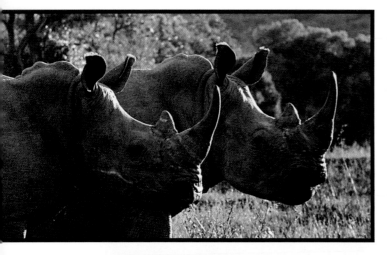

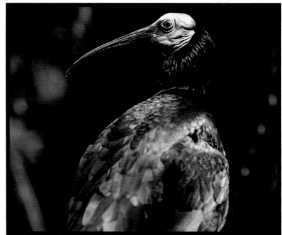

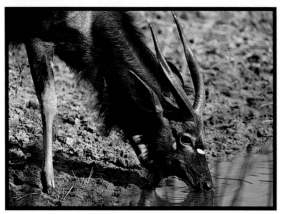

A fading light and again using a gentle back-light to compose the shot, with the help of a long focus lens, resulted in this profile of white rhinos. The interest in this double portrait lies mainly in the lighting, while the framing helps capture the detail which becomes central to the composition. Less dramatic is the Cape ibis, endemic to the northeast of South Africa where it prefers to nest on cliffs and escarpments. However, the weird face perfectly lit, also caught by telephoto, was interesting enough to capture.

The 340 square kilometer Giant Castle Reserve was created in 1903 to save the Cape eland – largest of the African antelopes – from extinction. Today they live peacefully alongside some sixty kinds of other mammals and more than 170 types of bird, including the curious Cape ibis, the majestic black eagle and the enormous bearded vulture. It also contains some of the finest surviving examples of San Bushman rock art in South Africa. Giant Castle has about fifty primitive sites of which the best known, Main Cave and Battle Cave, boast several hundreds of ancient paintings; while the 320 square kilometers of peaks, steep slopes and dense forests within Cathedral Peak, attract many climbers and walkers. With few birds, the stunning scenery is the refuge of the mountain reedbuck and the klipspringer.

Further north, the Royal Natal National Park, founded in 1916, includes the Mont-aux-Sources, which is the country's highest point at 3,282 metres, and an extraordinary mineral amphitheatre with enormous cliffs 500 metres high. The park's tortuous topography also gives birth to numerous rivers. One of these, the

The nyala (above) is a superb antelope with a similar profile to the kudu (opposite) whose habitat it sometimes shares. It is, however, smaller and the male's horns are less twisted than the greater kudu. It also sports a darker and longer coat. Both have an incredible grace, indeed their delicacy is apparent even when they drink. For tighter shots, a telephoto is recommended. And when the sun is not too high or when it starts to decline, don't hesitate to position yourself to get a gentle backlight, which always works well in animal shots.

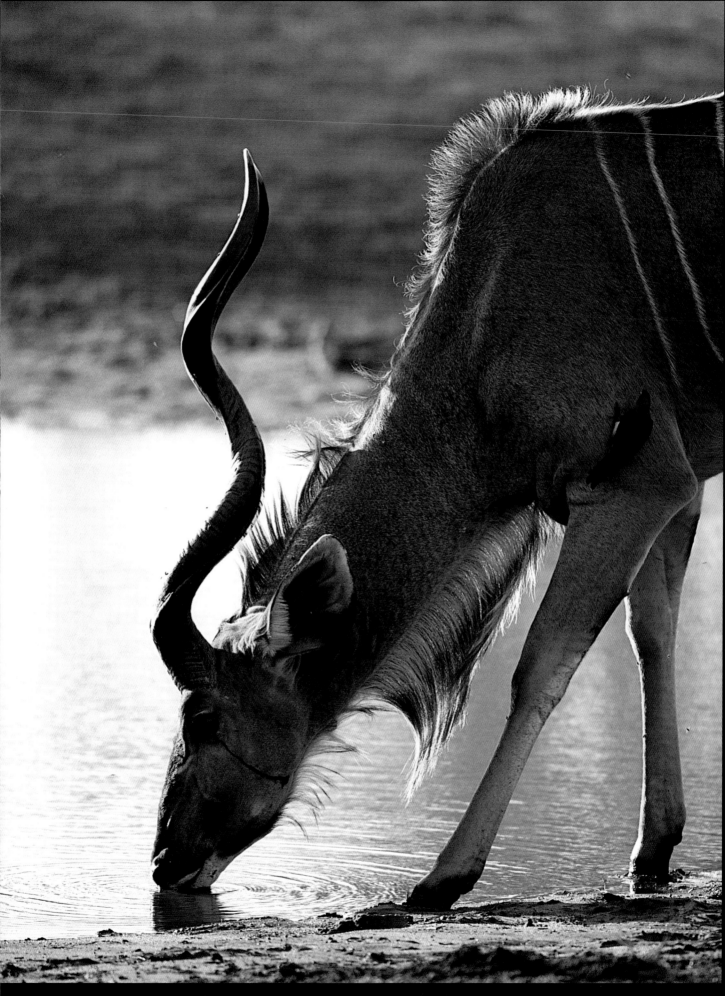

Tugela, boasts a beautiful series of falls before disappearing into a narrow gorge. The diverse flora of this park provides a veritable banquet for its many herbivores. Here, too, are not only the mountain reedbuck and the klipspringer but also the bush duiker, rock hyrax and baboon, not to mention some 200 different kinds of birds.

Going northeast, the Hluhluwe and the Umfolozi reserves should not be missed. Established in 1897 at the heart of the noble Zululand, these reserves were merged in 1989 to form a single entity of 960 square kilometers. Together, they constitute an area of more or less craggy undulations, vast wooded plains and superb waterside forests emphasizing river courses. These areas can be explored thanks to an excellent network of roads and footpaths guided by an armed ranger. Among the 84 types of recorded mammals, the white rhinoceros numbers more than 1,500, less than the number of antelopes, zebras and buffaloes but out-numbering black rhinos, elephants and giraffes. Lions, leopards, cheetahs and hyenas are natural predators for much of this prey. As for birds, more than 400 varieties colonise the skies of Hluhluwe-Umfolozi which has always been a wonderland for observing wildlife.

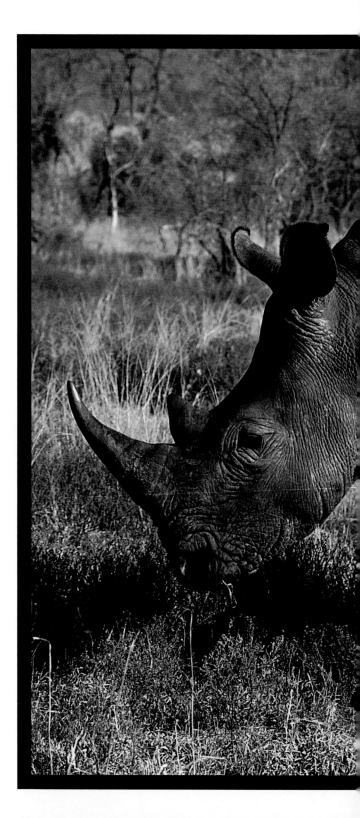

South Africa is undoubtedly the
sanctuary for rhinos whether black
or white. The photo below is of a
white rhino female with her young.
The baby rhino is born after a
gestation of 15-16 months and
already weighed 40 kilos at birth.

The white rhino is less shy and
sensitive than his black cousin, but
when with their offspring it is wise
to use a long focus lens so ensure
safety and not disturb the animals.
Such an encounter is, nevertheless,
a great privilege.

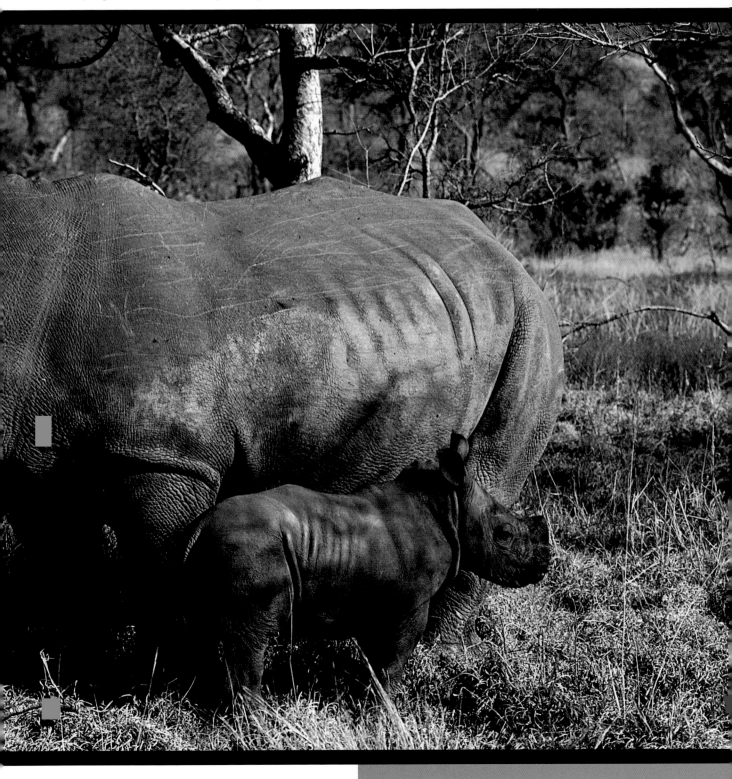

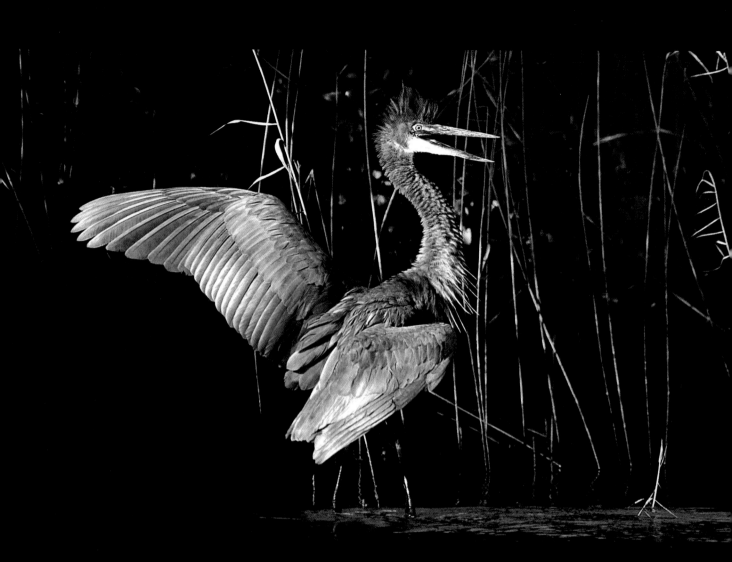

The Goliath heron is one of 400 species present within Greater Santa Lucia Park. The sanctuary was established in 1897 and extends over 275 square kilometres of wetlands. This old park actually groups several other nature reserves and protected areas, notably Lake Santa Lucia and the marine reserve of the same name. Like most birds, the world's largest heron is cautious and so it is best to use a telephoto lens when photographing its behaviour. Getting a good shot, however, means waiting silent and motionless for a long time. On other occasions, though, the situation can change very rapidly. While luck always plays a part in any successful wildlife shot, patience remains a key discipline which once the photographer masters will often be rewarded.

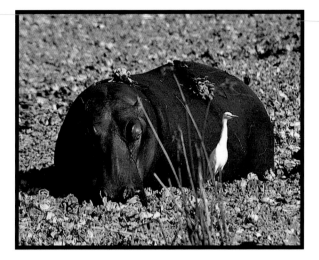

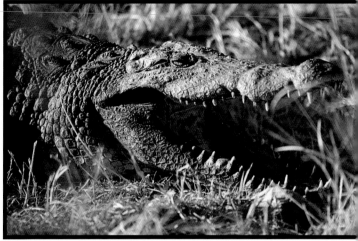

With an average weight of 3 tons, the hippopotamus is the third biggest terrestrial mammal after the elephant and white rhinoceros. Its huge size, as well as its irascible character, makes it the most dangerous animal of Africa, together with the buffalo. It spends the day in water, where it can move easily, thanks to its big webbed feet. It is particularly keen on swamps where the aquatic plants protect the bare skin from the strong sunlight and can be often found associated with cattle egrets, as here.

The hippo also tolerates oxpeckers – birds which feed on external parasites – on their exposed bodies. When present, this offers the photographer the chance to work with a telephoto lens from quite a distance to record the unusual co-operation between species. The same equipment can be used to record the biggest living reptile, the crocodile, whose expression remains menacing, even when it is fixed. The crocodile holds the record length among reptiles of 7.9 metres, while weighing 1.5 tons.

Towards the west extends Itala, a game reserve of 297 square kilometers created in 1972. Although many species had died out, many have been successfully reintroduced such as the cheetah and the brown hyena. More than 300 types of bird and 75 types of mammal today flourish in Itala which also hosts quantities of antelope including impala, kudu, nyala and wildebeest. They live alongside zebras and warthogs in a splendid setting of wooded savannah amidst abundant brushwood and hills gashed by deep valleys. Further east lies the Mkuzi Game Reserve in the foothills of Lebombo. Instituted in 1912, it covers 400 square kilometers. Its grassy planes and woodlands are sprinkled with scrubland and waterholes which welcome a large animal population that sometimes lacks predators. Birdlife is prolific here, notable species include the pelican, fish eagle, squacco heron, purple gallinule and jacana.

Along the edge of the Indian Ocean, adjoining Mkuzi, lies St. Lucia, a wetland designated by UNESCO in 1999 as a World Heritage Site.

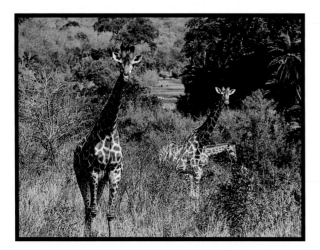

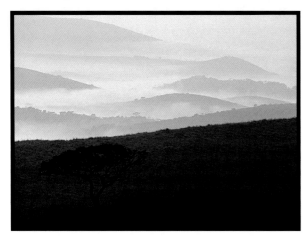

It regroups Mapelane Nature Reserve, Santa Lucia Wildlife Reserve and Sodwana Bay National Park into the Greater St. Lucia Wetland Park. These areas can also be visited by boat and mainly encompass dunes, reed-beds, mangrove, marshlands and a shallow lake. Such a rich environment inevitably attracts hippopotamus, crocodile and a multitude of birdlife (eastern white pelican, African spoonbill, avocet, heron, fish eagle, etc.) drawn by an abundance of fish, shellfish and insects. The marine reserves of St. Lucia and Maputaland form Africa's largest protected aquatic zone.

In the far northeast of the province, the neighbouring Ndumo and Tembe reserves adjoin Mozambique. Protected since 1920, the floodlands and marshes are fed by the Pongola, and Usutu rivers and make Ndumo an ornithological paradise. Among the 400 recorded types of bird are the pygmy goose, whitefaced duck and black egret in addition to such rare species as Pel's fishing owl and the southern banded snake eagle. Although predators are difficult to spot, hippopotamus, crocodile, buffalo and nyala are common. West of Ndumo is the Tembe Reserve which was opened to the public in 1991. It was designated in 1983 a shelter for elephants endangered by poaching and the Mozambique civil war. The elephants migrated regularly to and from Maputo Park (in Mozambique) and Tembe Reserve, where they have now settled. About 150 elephants share their swampy territory of subtropical forests and bush with other wildlife and 360 varieties of birdlife, such as the sunbird, the lourie and the roller. Away from the tourist routes, the wilderness of KwaZulu-Natal affords a wonderful discovery of a heritage set amidst luxuriant vegetation.

Here is a nice encounter with a giraffe family. The calf, which weighed 60 kilos at birth, already measures two metres. It begins feeding on leaves from the age of two months. They seldom fall victim to predators because the mother will vigorously defend them from attack with a flurry of violent hoof kicks. When composing the shot, use a telephoto lens to avoid disturbing these peaceful creatures as you approach. The shot opposite is of a hefty 200-kilo waterbuck whose horns can grow up to one metre long. When shooting on a misty morning, a standard focal length lens suffices when seeking out detail for your picture.

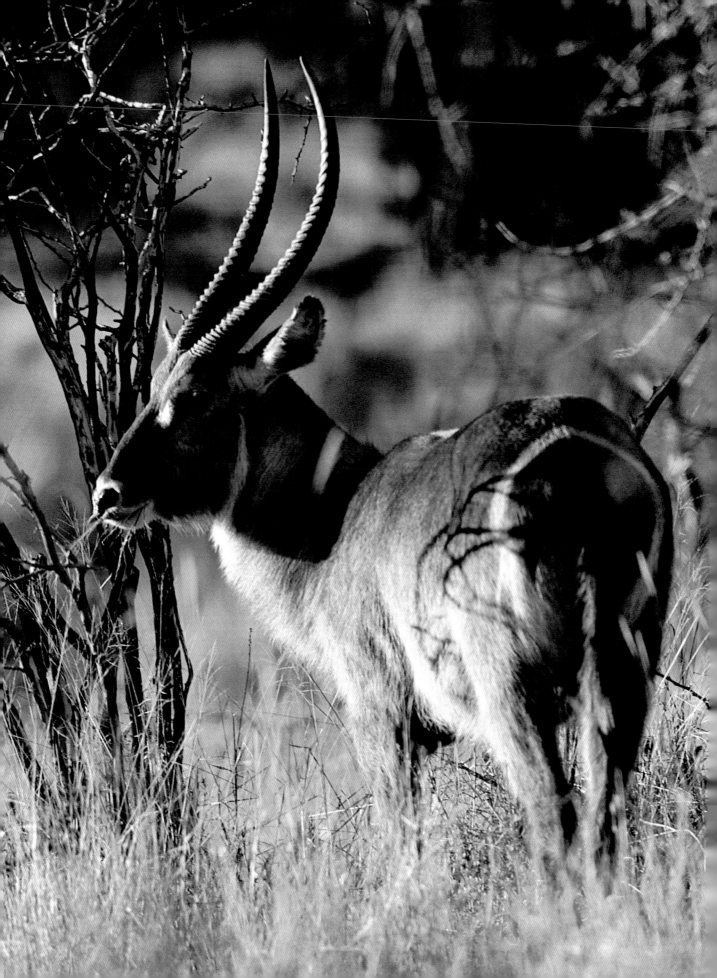

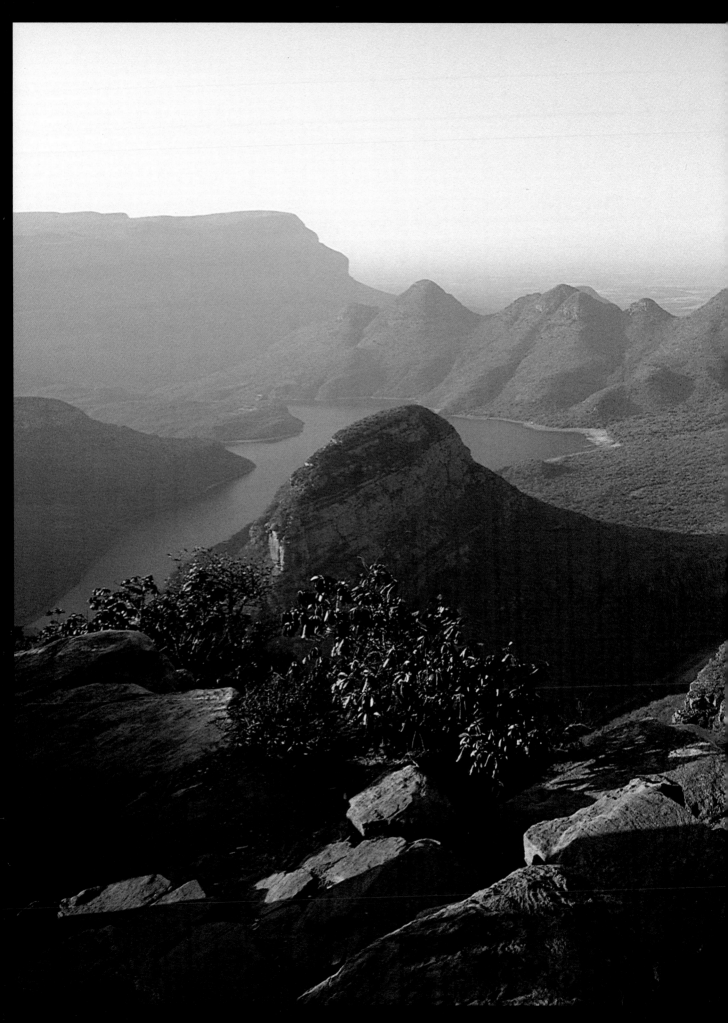

Blyde River Canyon

The majestic scenery of Blyde River Canyon unfolds on the Little Drakenberg plateau. Carved by this tumultuous river, the canyon has been a nature reserve since 1963. Its surface – which has already expanded five-fold – currently covers 260 square kilometers.

It encompasses a thrilling diversity of cliffs, plateaux, prairies and small valleys, wherein flourishes a wealth of trees and sub-tropical flowers. Along this vertiginous fault is the world's third largest canyon after those of the Grand Canyon in the United States and Fish River Canyon in Namibia. It meanders for almost 30 kilometres, dropping to depths of 800 metres. In doing so, it reveals curious geological features observable from stopping places along the tourist lanes or from the reserve's many footpaths. In particular, the Three Rondavels should not be missed!

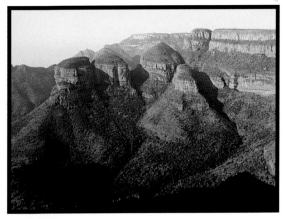

At the divide between the high plateaux of the west and the scrubby savannahs of the east, the spectacular Blyde River Canyon is shaped into the basalt escarpments of Little Drakensberg. As always, it is best to photograph landscapes at the beginning or end of the day to get the best lighting. The heat haze and sun, when it's not too elevated, enhance the contours and vegetation. A wide angle and medium focal length lens are once again recommended.

These are the strange rocky formations that plunge into the splendid blue waters of Lake Blydepoort. Further south, the unusual cylindrical cavities of Bourke's Luck Potholes – set within grey and ochrous cliffs – are also well worth a detour! Elsewhere, evocative names like Wonder View, God's Window and Pinnacle are invitations to contemplate other natural edifices contributing to the reserve's scenic beauty. More than just a stopover en route to Kruger, this protected area is somewhere worth lingering awhile.

There are some 9,000 elephants in Kruger Park, particularly visible at rivers where they meet for ritual ablutions or simply to drink. The Sabie River is one of their favourite meeting places. The only difficulty is to locate a clear viewpoint. Like all social animals, the activity of elephants is always fascinating. For the best results, choose a long focus lens and an early morning light in order to capture the rough texture of the pachyderm's hide.

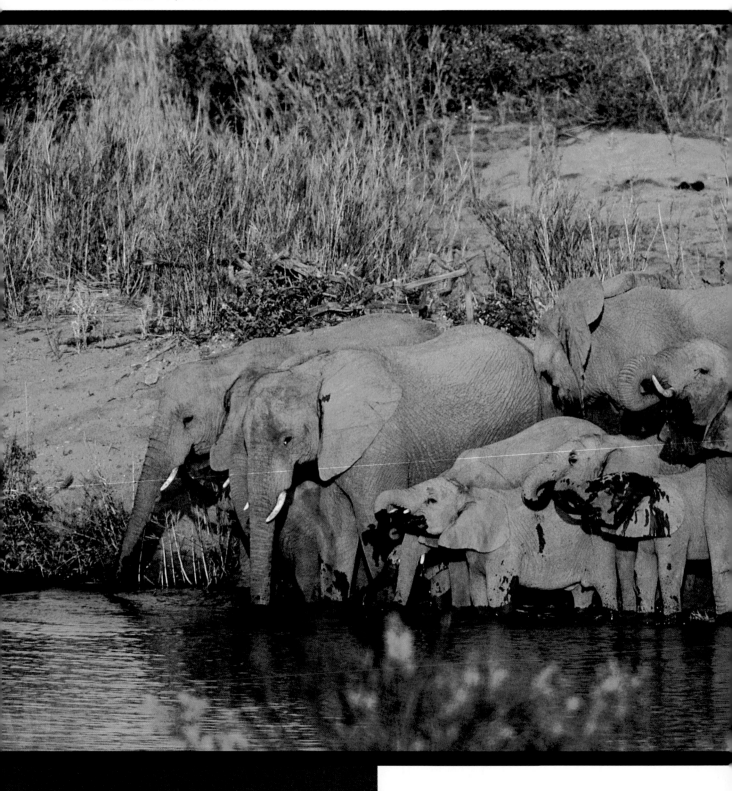

Kruger

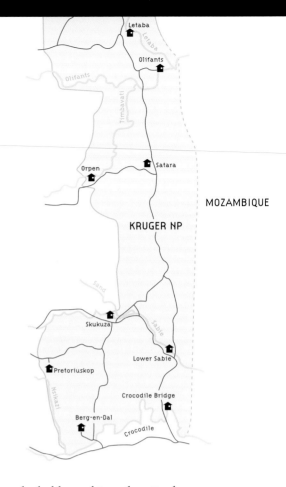

It was at the bidding of President Paul Kruger that the nation's first animal park, Sabie Game Reserve, was created in 1898. Five years later the neighbouring Shingdwezi Reserve was proclaimed. It was not until 1926, however, that the two sanctuaries were united under the leadership of a Scot named Major Stevenson-Hamilton who retained this role for the next 40 years. A pioneer conservation programme was rigorously implemented which transformed Kruger National Park into a model of environmental management and a major African tourism attraction. The hospitality and road infrastructures are often equal to the best of western standards but at the expense, perhaps, of a more picturesque and escapist ambiance. Once off the main roads, however, it is possible to explore the park on dusty, rocky tracks.

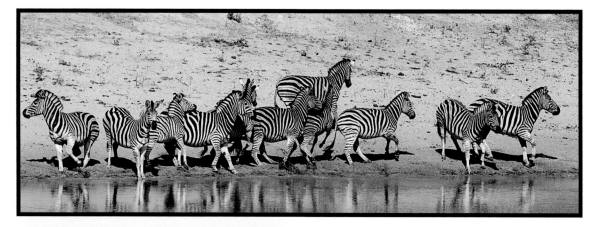

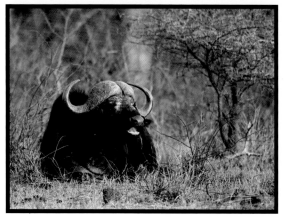

Kruger covers an area of almost 20,000 square kilometers and is about 350 kilometres long and 60 kilometres across. It is traversed by 2,600 kilometres of roads and tracks which are mainly concentrated in the southern half. Located in the north of the country, Kruger National Park is contiguous with Gonarezhou national parks in Zimbabwe and Coutada Hunting Reserve in Mozambique with which it merged in 2002 to form Africa's second trans-border park after Kgalagadi – the Great Limpopo Transfrontier Park extending over 35,000 square kilometers. The same Limpopo River marks the natural border in the north between the Kruger and Zimbabwe, a region shaped by hills, and in the east by the Lebombo Mountains which separate Mozambique. In the south, following the Malelane plateau, the Crocodile River defines the park's limits. Finally, in the west the foothills of Little Drakensberg separate it from the rest of the province.

The Kruger essentially comprises a dry savannah marked out by rocky outcrops and where the bushvelt alternates with more densely-wooded areas. Apart from a multitude

The traditional 24x36 format of the 35mm camera doesn't always accommodate the intended composition. Sometimes a panoramic format works better as shown by this shot of lively zebras at the edge of a waterhole. The photographer, having no choice but to shoot from the opposite bank, had to use a long lens for this scene.

Identical equipment was used in making the portrait of a buffalo stretched out near its herd at dusk. As for the ground hornbill, a long lens, with a teleconverter was used for a dramatic head-on crop. This bird spends two-thirds of the day on the ground searching for food and sometimes attacks predatory birds in their nest to steal their prey.

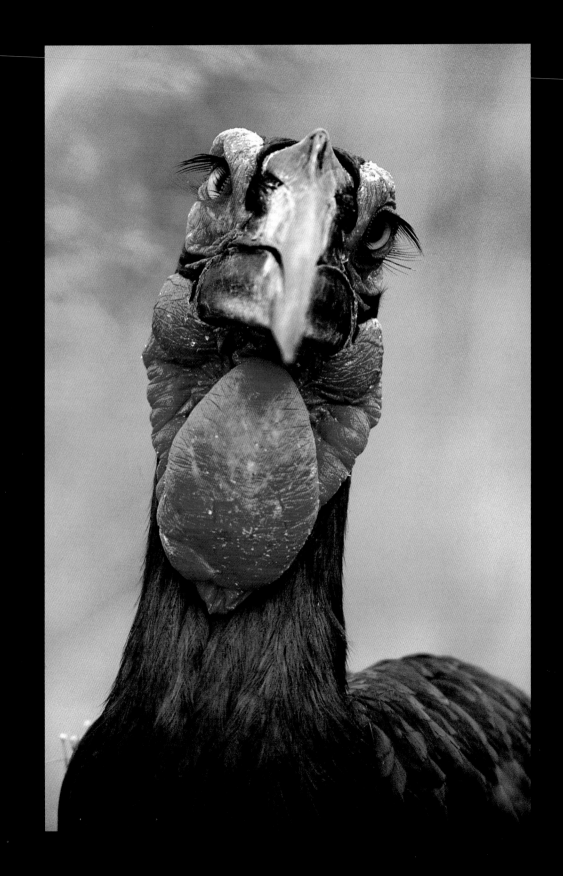

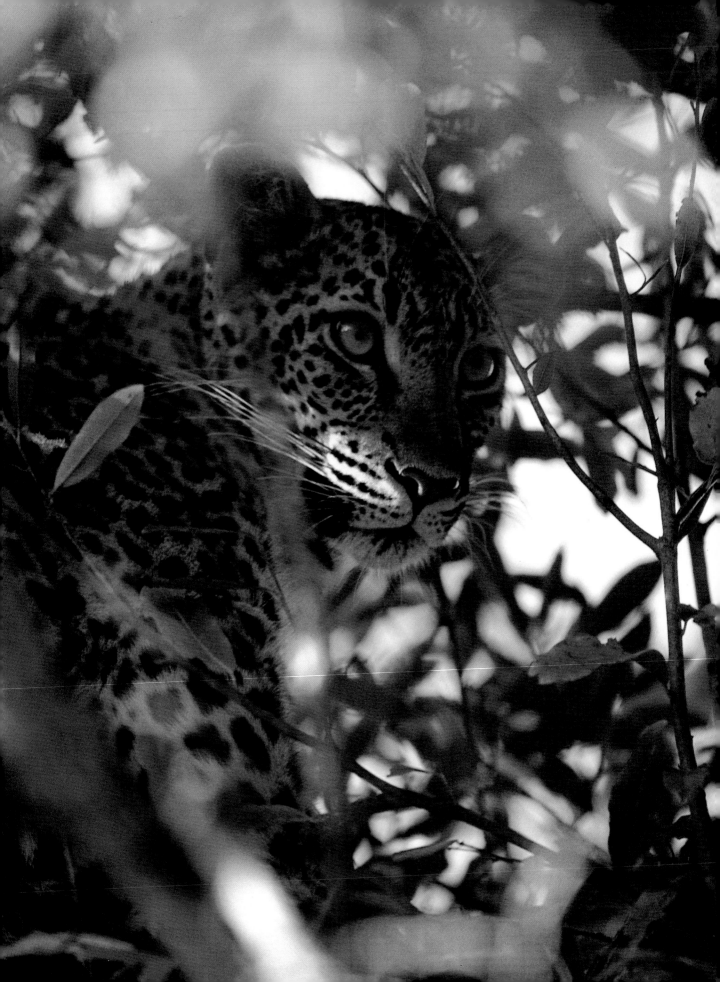

The steenbok is a small territorial antelope, usually active in the morning and evening, preferring to stay under cover during the heat of the day. A telephoto lens is useful in getting a shot of this rather scared creature. As for the wild dogs they are an endangered species and the Kruger is one of its last sanctuaries. They live and hunt as a pack. An accomplished hunter, the wild dog operates over wide areas and carefully avoids its worst enemy, the lion. Untroubled by the gaze of visitors, this wild dog tolerates having his picture taken with a medium focal length lens.

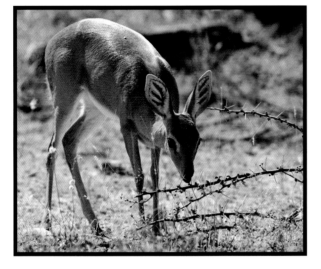

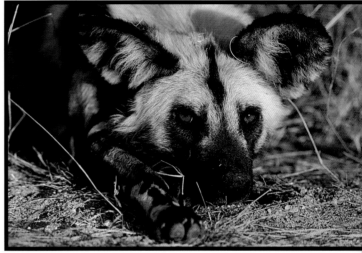

of seasonal streams and waterholes, six permanent watercourses – the Shingdwezi, Luvhuvhu, Letaba, Olifants, Sabie and Crocodile – slice through the park. Linked to summer rains, this hydrology system contributes to the region's rich fauna and flora.

The Kruger's geography, however, reveals nuances and defining it statistically induces vertigo! Some 16 ecosystems, about 140 species of mammal, more than 500 species of birds, 115 reptiles and more than 2,000 varieties of plantlife make Kruger a naturalist's paradise. To the north, the undulating Punda Maria terrain is covered by scrubby mopane trees mixed with willow bushes and baobab trees. Here elephants flourish as do buffaloes – widespread throughout the park – and some of the more attractive African antelopes like the sable

The camouflage of the leopard's coat, coupled with the dense vegetation, make it a difficult animal to spot, especially since it spends most of the day resting in trees. If the sunlight penetrates the foliage, a shot can be interesting. In certain circumstances, like here, it was necessary to add a teleconverter to a long focus lens to fill the frame with the subject. But the character of the shot emphasises the camouflage and shows how difficult it is to photograph.

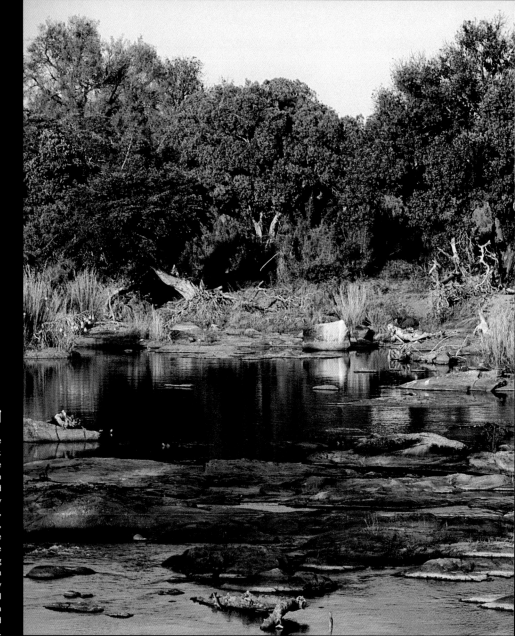

The Sabie is one of the permanent rivers of the Kruger. It winds through the south of the park where it provides a haven for numerous birds and mammals. It is particularly appreciated by elephants, buffaloes, hippos and, of course, crocodiles. For a memorable photograph, it is best to use either the warm early morning or late afternoon light. Pick a clear viewpoint and avoid a bushy foreground. A medium focal length lens gives a composition which concentrates the eye and enhances features of the setting.

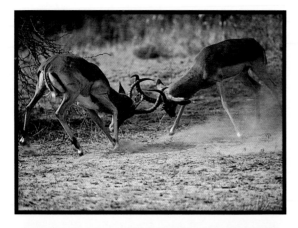

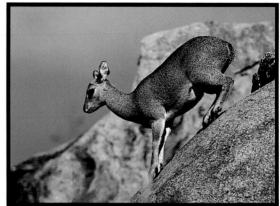

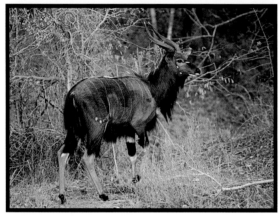

At rutting time the male impala engage in vigorous combat in order to defend their territory and their harem. Not so with the klipspringer, also called the rock jumper antelope due to its exceptional agility in the rocky mass and scree where it lives. It can make spectacular jumps of several metres to escape a predator and land without injury. The elegant nyala is neither territorial nor polygamous and lives in constantly changing groups. To photograph all these animals a long focal length lens is preferable, since it avoids disturbing them.

antelope and its cousin, the roan antelope, the majestic Cape eland and the nyala. In the northeast, the same species frequent the rocky mountains of Lebombo from where they escape along the parched riverbeds which guide them to the Shingdwezi River.

Further south in the Letaba district, a thick shrubland cover is again dominated by mopane trees. This steep terrain is the kingdom of the klipspringer and the tsessebe, the latter distinguished by its elbow-shaped horns. At the park's centre, the banks of Olifants River give way to an unusual landscape offset by steep cliffs. Dark rocks litter surrounding plains that are dotted with acacia, sycamore and marula trees and whose fruits and leaves, in turn, nourish the wildlife. To the south, the fertile Satara plains provide excellent grazing for zebras and gnus which, along with the buffaloes and elegant impalas, form Kruger's main population of herbivores and mix with many greater kudus. This animal concentration represents a plentiful food store for the lions, cheetahs, wild dogs, spotted hyenas and jackals which seldom dare to attack the black rhinos for which this region is noted.

Giraffe live in informal groups but nevertheless submit to a hierarchy headed by the males. To ascend the hierarchy or to preserve their position, the giraffe battle with their rivals. Intimidating postures and clashes of their long necks make for a gracious combat, more spectacular than dangerous. A telephoto lens generally allows you to capture the action without interfering with the animals. The same focal length was used for the hippopotamus. When he regains his breath after five minutes underwater, you have to be ready to shoot. The spray thrown into the air was perfectly lit by the lateral evening sun subtly filtered through the vegetation.

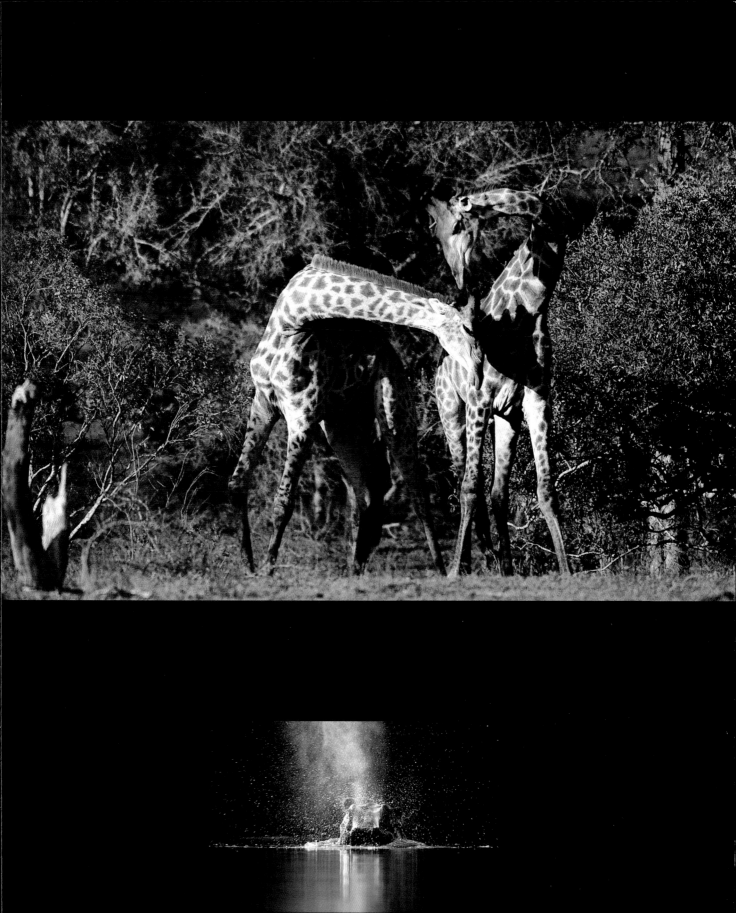

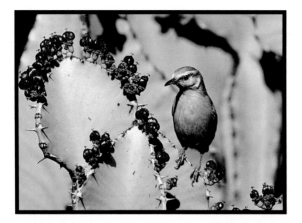

It is not always necessary to travel miles and stand motionless for hours gripping a telephoto lens to photograph birds. It took only a simple walk in the camp's enclosure to photograph, with a medium focal length lens, the spottedbacked weaver, whitebellied sunbird, spectacled weaver, starling and many others. The golden rule is to learn how to approach such birds discreetly on foot, always avoiding sudden movements.

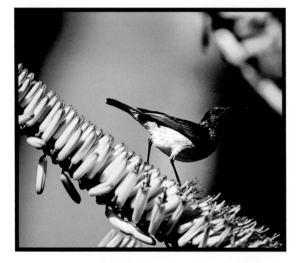

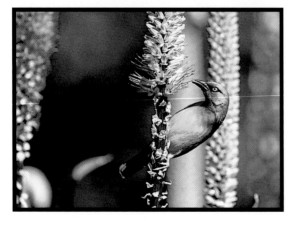

Monogamous and territorial, lilacbreasted rollers live in groups of varying size in open savannahs and thin forests where they feed on insects and small lizards. This emblem bird of South Africa with its colourful plumage makes a good photo subject. If you wish to shoot it full frame, a telephoto lens with teleconverter is recommended.

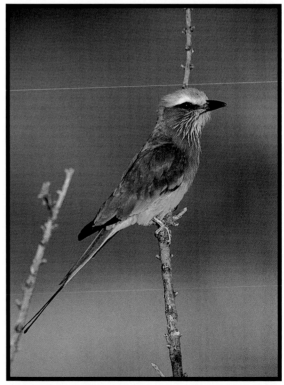

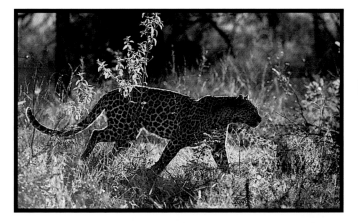

When the sun is low in the sky, do not hesitate to try backlighting which always produces the best results when emphasizing the contours of a leopard or other animal. But this type of shot can only succeed with a medium or long lens depending on the distance from the animal. The same equipment was used for capturing this lioness stretching in fading afternoon light. A telephoto lens also proved to be the best approach for taking a young cheetah hiding in a tangle of grasses and a pair of wild dogs away from their pack.

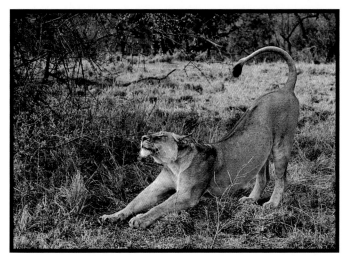

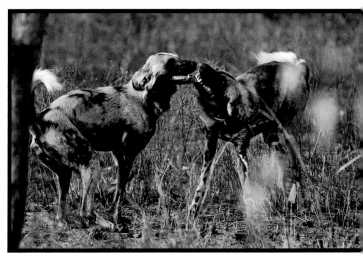

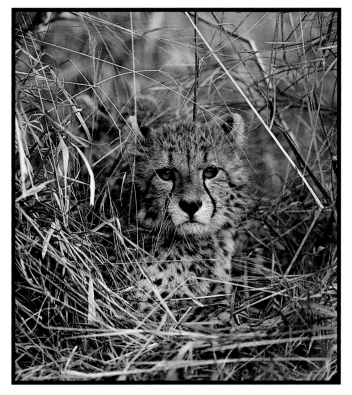

Towards the Sabie River, which links the Skukuza and Lower Sabie camps, the horizon opens on to a vast bushland where, depending on the season, the bright scarlet of the coral tree radiates. Once across the Sabie, light forests extend over the undulating terrain in the widest part of the park. They host most of the species already mentioned including a sizeable number of white rhinos that have designated this the perfect habitat. The nyalas, bushbucks and waterbucks live in the wooded galleries alongside the permanent rivers. The tangled vegetation offers protection and sustenance and, in the shade of giant trees, they are

joined by other fauna searching for water during the dry season. Vervet monkeys and baboons also appreciate these woodlands where the leopard hides and lower down reside the hippopotamus and the crocodile. Significant populations of birdlife colonise these waterside areas. Diverse species of heron and small waders walk beside hamerkop, jabiru and crested guinea fowl while the tree tops shelter big birds of prey like the martial eagle and the black eagle without mentioning the presence of vultures and owls. The carmine bee-eater, paradise whydah and the lilac-breasted roller are among the multitude of iridescent birds that illuminate the green branches. The Kruger presents one of the most beautiful examples of African wildlife and is an essential part of any trip in South Africa.

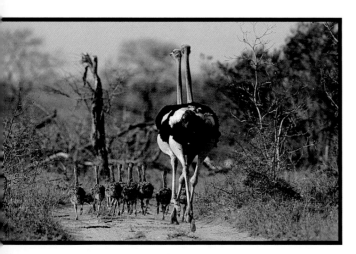

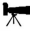

The warlike antics of the hippopotamus are a wonderful spectator sport. Several times these animals burst out of the water in perfect morning light. Look for eddies in the water that indicate the presence of hippos so that you can anticipate their movements. Armed with a telephoto lens to get a shot that fills the frame, a fast shutter speed must be used to freeze this gush of splashing water because the scene will only last a few seconds. The same lens and speed were needed to photograph a less energetic shot of a crèche of ostriches out on a jaunt.

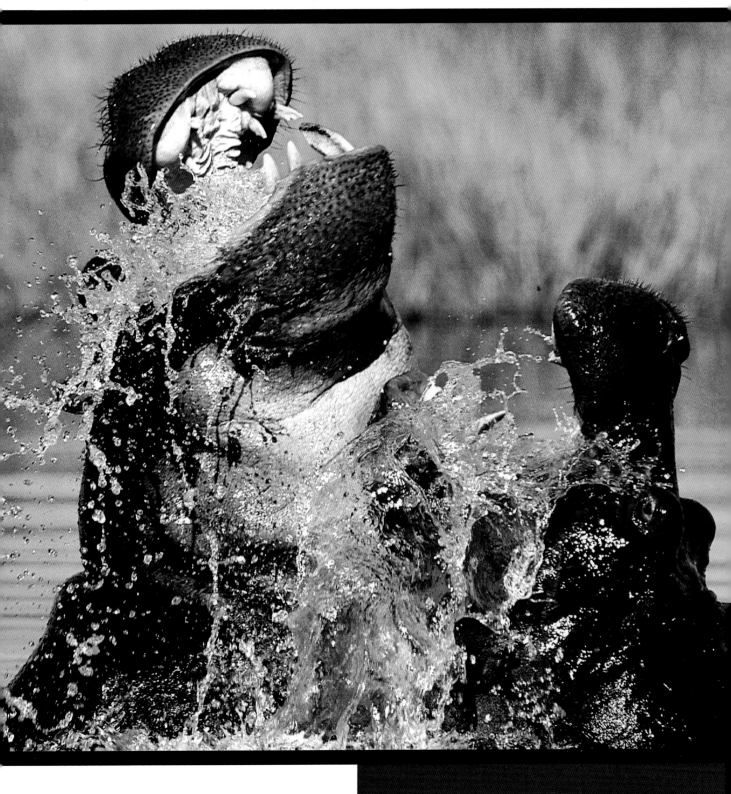

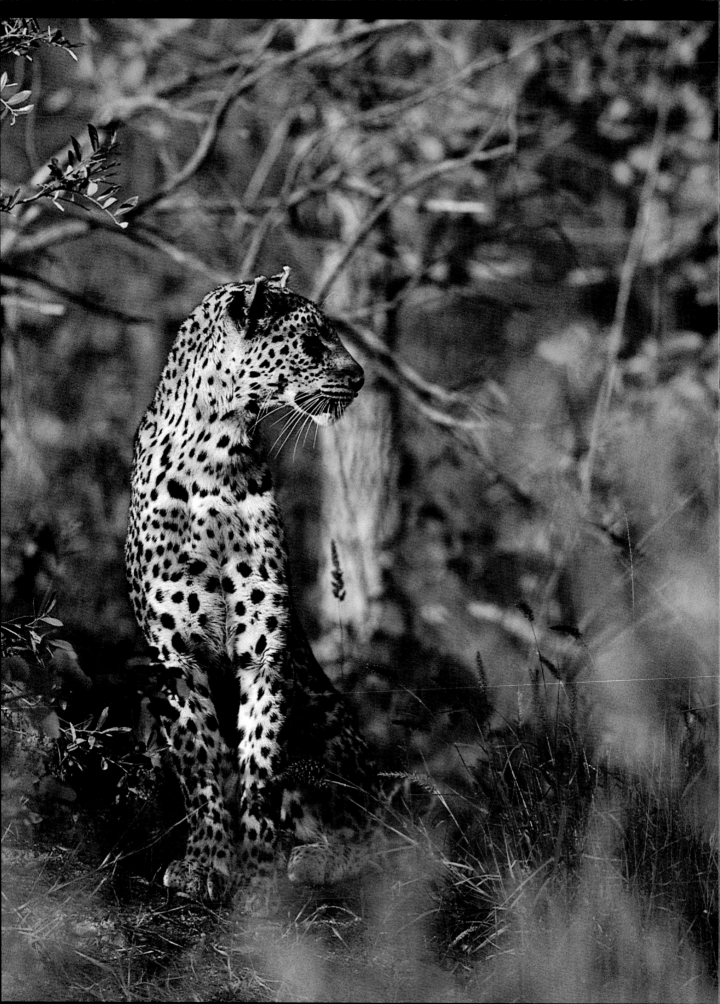

Private reserves

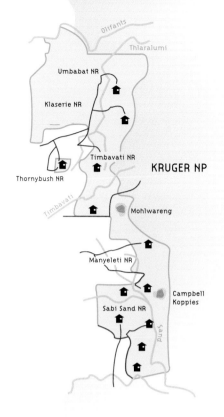

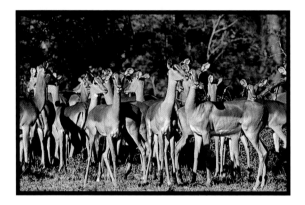

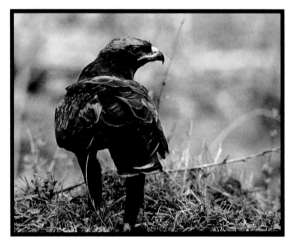

South Africa's main private reserves are to be found in KwaZulu-Natal or, for the better-known ones, to the west of the Kruger National Park where they share the same wildlife and vegetation cover. Many of them adjoin one another and are without separating fences. Thanks to a shrewd road system, these reserves are not accessible from within the Kruger so as to preserve a certain air of privilege. Their land areas vary in size from 80 to more than 650 square kilometres and cumulatively occupy about 5,900 square kilometres.

Administered by landowners or by provincial authorities that consult with local tribal councils, some reserves devote part of their land to research and education programmes while others receive tourists. Each reserve is divided into various private plots on which lodges have been established to accommodate visitors and

The leopard is so difficult to spot that only the private reserves, where it is closely followed and observed, can virtually guarantee a sighting. The dense bush does not greatly facilitate photography. A long focus lens, therefore, is often needed and one should not fear incorporating a bit of foreground vegetation. With a reduced depth of field, it will appear fuzzy and will lead the eye to the subject beyond. Use the same lens for the impalas where the male and female herds live apart except during the rutting season. Of course, for large birds like this lesser spotted eagle the telephoto lens remains indispensable. It is unusual to encounter this migrating eagle which nests in eastern Europe as well as in west and south Asia. You will need to be quick and quiet if you want to get a good picture. This eagle is on the ground, feeding on termites and insects which constitute its basic diet.

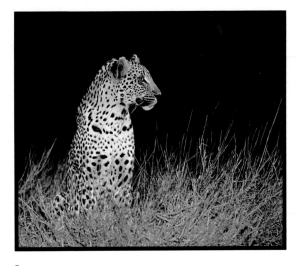

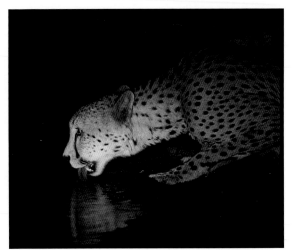

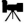

A medium focal length lens with a flash set at half power, were the essentials tools for this leopard's portrait. These are discreet felines whose kingdom is the night. The leopard generally waits for darkness before hunting or relocating from one place to another. As for this cheetah, it needs to drink before seeking a refuge for the night because it is a daytime predator. This one was willingly photographed without flash and only the torch light used to locate him was used for the shot. Along with the use of regular daylight standard film, it gave this picture a very yellow tone. It produced an interesting effect which perhaps better reflects the atmosphere of the scene.

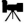

Like most predators, the most sociable of the felines – lions – are active after nightfall. If the females decide not to hunt, they remain within the pride, mutually grooming one another, suckling or playing with their offspring, which allows for some original photography. The off-road shots call for the use of a medium focal length lens with the essential flash set to half-power to avoid making the nocturnal mood seem unnatural.

organise their drives within the reserves. These splendidly managed and decorated establishments offer, for the most part, an exceptional degree of luxury and comfort that visitors will not easily forget. But at all times the primary interest of a safari at the heart of a private reserve is to assure the best conditions for observing wildlife. On board each lodge's exclusive vehicles, visitors are led by a ranger who doubles as chauffeur-guide and by a tracker, both of whom are very professional. The former provides information on matters relating to the natural habitat, while the latter deciphers animal traces to locate their whereabouts. At the request of their clients, the object of greatest interest is usually a predator. The result of this collaboration is an almost guaranteed success. In South Africa, the wildlife professionals at the service of tourists are university educated which, coupled with their knowledge of local field conditions makes them particularly efficient. They know perfectly the setting, the animals — sometimes individually — their habits and their territory. Consequently, they can find them with comparative ease.

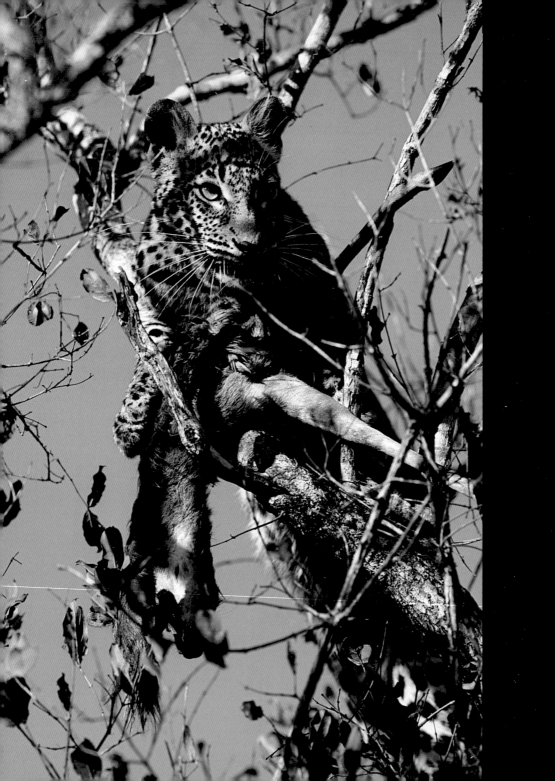